Chinese Ink painting

Chinese Ink painting

Techniques in Shades of Black

Jean Long

BLANDFORD PRESS
POOLE · DORSET

First published in the UK 1984 by Blandford Press, Link House, West Street, Poole, Dorset, BH15 1LL.

Copyright © 1984 Jean Long

Distributed in the United States by
Sterling Publishing Co., Inc.,
2 Park Avenue, New York, N.Y. 10016

British Library Cataloguing in Publication Data

Long, Jean.
 Chinese ink painting.
 1. Ink painting, Chinese—Technique
 I. Title
 759.951 ND2068

ISBN 0 7137 1491 3 (Hardback)
 0 7137 1490 5 (Paperback)

Typeset by Poole Typesetting, Bournemouth
Printed in Great Britain by R. J. Acford, Chichester

Contents

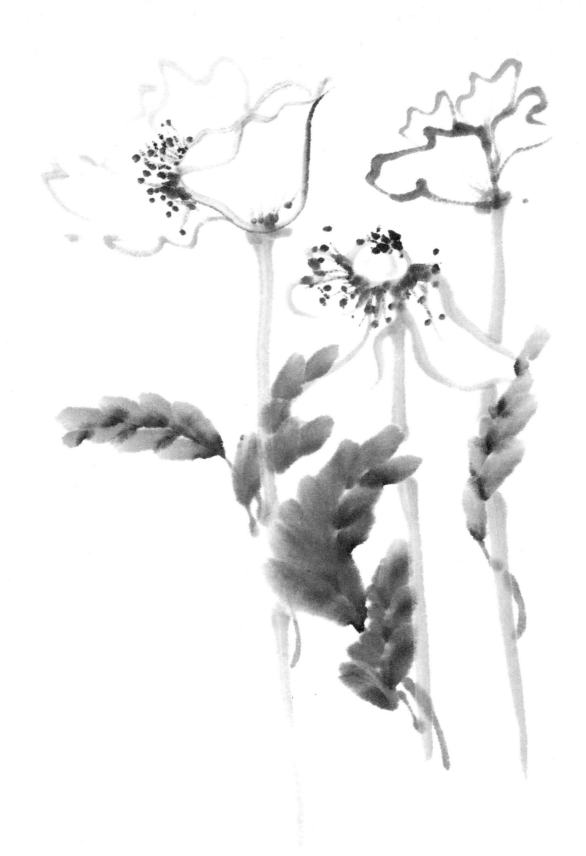

Introduction

The intention of this book is to describe and demonstrate some of the possible subjects which lend themselves to the traditional monochrome Chinese painting techniques – where the variations in colour, in texture and in depth are all achieved by 'shades of black'.

Chinese painting techniques are very different from those of Western water-colour painters. They are based on traditional methods which have been maintained over a number of years by devotees of the art who have helped to keep alive all that was good in Chinese brushwork.

The Chinese brush and paper are soft and gentle and require a unique response from the artist to the physical act of painting. There has to be a total absorption in the act of painting to enable the nuances of light and heavy, flow and pause, fast and slow to materialise spontaneously. A whole new world of perception can be developed through the art of Chinese painting.

Even for the Chinese, instant results are not obtainable. They know and appreciate the value of practice. To be able to manipulate freely the shades of black required for the paintings cannot be discovered without considerable practice.

From the hours of practice comes control: the skill of knowing how and where to stop; the development of knowledge which unconsciously helps the painter to understand how much water and how much ink to use. The amount of brush pressure needed at each stage of the painting is also acquired subconsciously by continuing practice. The control of this new working medium gradually becomes instinctive, enabling thought to be given entirely to the content and the composition, instead of to the technique.

The technique is essentially the method of working and involves not only the use of the equipment, but the control of oneself. To be in readiness for painting is also to be relaxed and at ease with oneself, and this, too, needs practice.

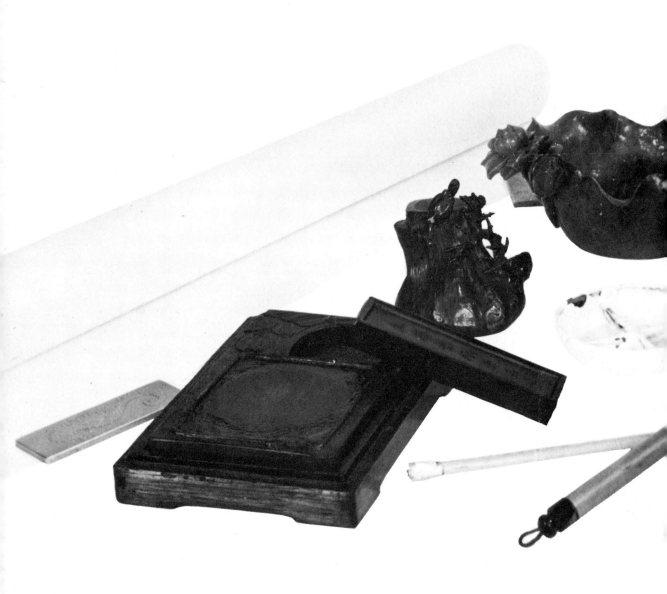

Chinese Painting Equipment

The Four Treasures of the Studio

The brush, the ink stick, the ink stone and the paper – the implements needed for Chinese traditional painting and writing – have been known as the 'four treasures of the studio' since the end of the 10th century when there was a shop of that name selling the equipment in Anhui province. These 'treasures' are the basic necessities required to paint traditional Chinese subjects in 'shades of black'.

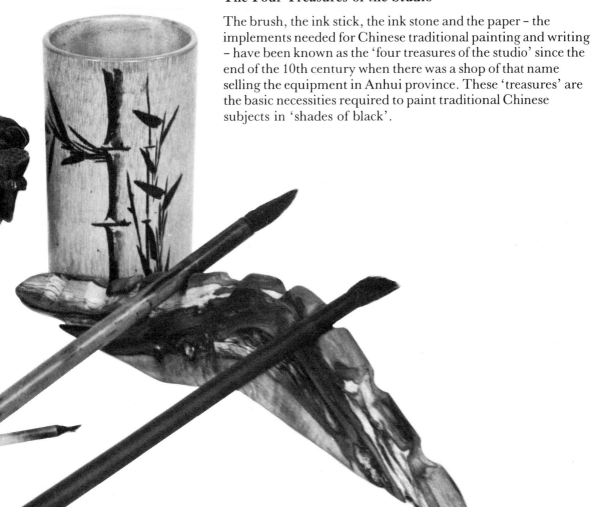

Accessories

In addition to brush, paper, ink stone and ink stick, the painter needs a water-holder, a plate or porcelain dish for mixing the black ink with water to make the shades of black, and newspaper to serve as the absorbent backing for the Chinese paper. Weights are also needed to hold the paper in position. There are also three

special items included here: a wooden 'mountain' brush rest, an antique water dropper in the shape of a bird on a tree trunk, and a lotus leaf brush-washer. (Those shown are from the collection of P. Cherrett).

Chinese Painting Brushes

All derive from the writing brush, but early writing was done with a whittled, sharpened willow stick on strips of bamboo. General Meng Tian who lived in the Qin Dynasty (221-206 BC) is credited with the invention of the brush of hair. In the story relating to this, it is said that as he was supervising the construction of the Great Wall he saw a tuft of goat's hair stuck to one of the stones, noticed its resemblance to the willow stick and tried to write with it.

The brush most used at present is a blend of the hairs of the weasel and the hare, but rabbit hair brushes, goat hair brushes, or even those made with panda hair or mouse whiskers are still available.

Much care is needed in the making of a brush. For instance, a brush of rabbit hair requires hair which is neither too soft nor too thick and has, therefore, to be obtained in the autumn when all the correct conditions are satisfied. The Chinese believe that every painter should possess his own brushes which, after training, take on his own personality and character. Although Chinese brushes are numbered, there is not always total consistency amongst the different makers. The centre brush in the illustration is a medium-sized one. The bristles are approximately 1 inch in length. The cost of brushes varies according to both the size and the type of hair used in the brush.

An assortment of brushes, from small to large, is also shown.

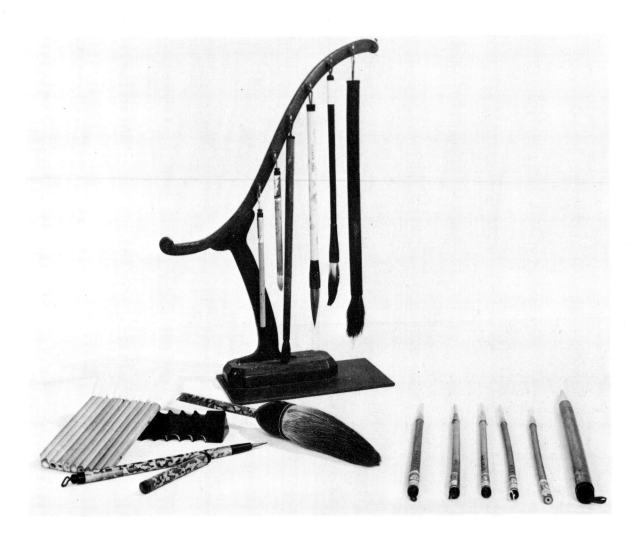

Some are hanging from a special rack (only to be used when the brushes are completely dry); a multiple brush, made up of ten small brushes glued together and used for washes, is lying on a wooden polished brush rest; a bamboo 'fountain brush' with its cap at its side is available for calligraphy; a set of six matching brushes demonstrates the range of brush sizes available and helps show the comparison between the popular sized brushes and the huge brush lying next to them.

The Chinese brush always returns to a fine point when it is wet, but its uniqueness lies in its versatility. If the painter wishes, the brush can produce strokes of varying degrees of broadness, or even split itself into two or more points to produce multiple lines with a single stroke. It is usual in ink painting only to use one brush throughout, as the brush will be capable of painting everything from the finest line to broad areas of wash. It is also

extremely helpful in maintaining the unity of brushwork style in the painting to use only one brush.

The Chinese brush is made up of hairs of varying lengths, bound together in a very special way and set in a bamboo holder. It is built round a central core, increasing in circumference as layers of hair are added to the core. When the correct size has been reached, the bundle of hair is tied, glued and inserted into the open end of a bamboo handle. (Care has to be taken not to loosen the glue in these brushes, as this is its weakest point. Hot water should not be used for brush washing. If the hairs do come out of the handle, they usually remain tied together in the bundle and can be re-inserted and glued with a modern glue.) A brush from the Western world has a large amount of hair inside the handle, while the opposite is true for an oriental brush. This special construction enables the brush to behave in a unique way when loaded with ink.

The stages in making a brush.

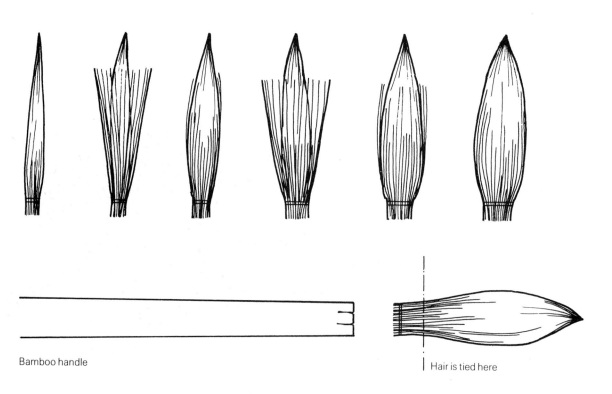

Bamboo handle

Hair is tied here

Preparing the Brush for Painting

Before actual painting can begin the Chinese brush has to be 'broken in' if it is a new one, not previously used.

First, the cap should be removed. This is sometimes bamboo, and nowadays may even be made of plastic. It should then be

thrown away and not put back on the brush as its use was to protect the brush during its travels.

Next, the coating of starch, used to shape and protect the hairs should be removed by dipping the brush in water and gently manipulating the point against the side of the paint dish, or even, very gently, massaging with the fingers.

Looking after the Brush

The brush should always be washed at the end of its use, taking special care to remove all traces of the black ink, which dries into a gritty state and would damage the brush if left in the hairs for a long time.

Brushes should be dried in the air by being laid down horizontally with the hairs suspended over the edge of a plate or ink stone. Traditionally, painters used a brush rest, often made in the shape of a mountain, to rest the damp brushes while in the process of painting. For Chinese painting it is important to be extra careful with excess water or dampness as the absorbency of the paper puts it more at risk than in ordinary Western watercolour painting. However, brushes should not be left to dry on the ink rest or the moisture seeps down to collect at the base of the hairs and may loosen the brush from the handle.

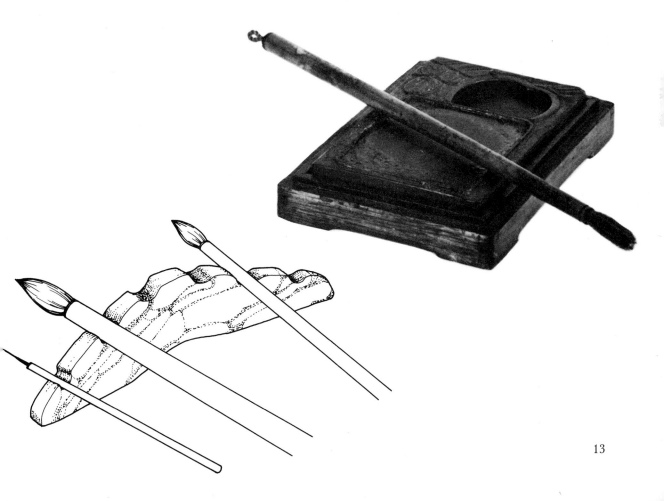

The Ink Stone

To make the black ink, the ink stick is rubbed in water on an ink stone. The grinding action rubs ink from the stick, enabling it to mix with the water. The finer the grain of the ink stone, the smoother the ink becomes and the longer the time needed for grinding.

The stone should be extremely smooth and hard. The most famous ink slabs are said to be from the Anhui district of China, where most are made from black stone, but there are also varieties with red or green markings forming designs in the stone.

Ink stones.

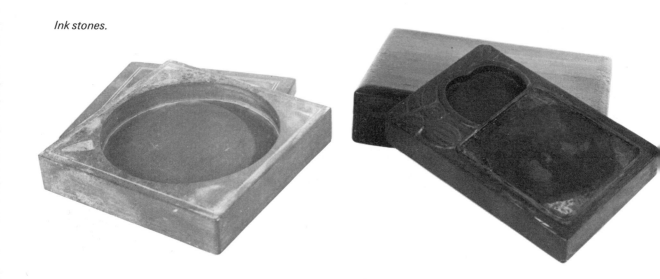

The Ink Stick

Old Chinese ink is made of pine soot mixed with glue and other ingredients to hold it together. It comes compressed into the form of a stick, sometimes round, sometimes square, decorated with characters and pictures in gold. Other ink sticks are made from lampblack mixed with varnish, pork fat, and musk or camphor; these have a lightly bluish, metallic tinge to them. (Tradition says that if this ink stick is rubbed on the lips or tongue, it is considered a good remedy for fits and convulsions).

A good ink stick is light in weight and very brittle. The best ink sticks produce a black which does not stick the brush hairs together, or fade with time.

The size of the ink stick should be compatible with the size of the ink stone on which it is to be rubbed and able to make an amount of ink suitable for the subject matter and painting size required. Large bamboo paintings need a large ink stick, ink

stone and brush; but a short piece of writing will not need so much ink to be made, so the stick and stone can be smaller.

The ink stick wears down very slowly with use, but the ink stone will last forever.

Mixing the Ink

Before beginning to paint, the artist always prepares fresh ink. Although Chinese ink is available in bottles, it is not suitable for painting nor does it generate the variety of tones, from deepest black to delicate pearl grey, which can be produced by the Chinese ink stick. The action of rubbing the ink stick in the water on the ink stone has the psychologically meditative effect of preparing the mind for the painting ahead, and as such has always been regarded almost as a sacred rite.

To mix the ink, first put some clear water into the well of the ink stone. Hold the ink stick upright and dip one end into the

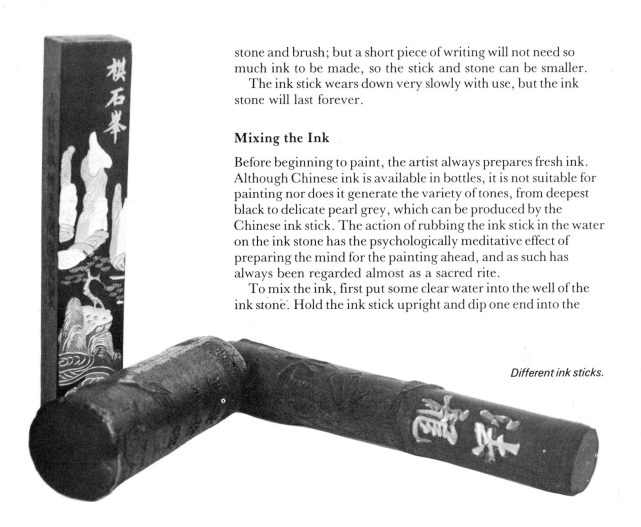

Different ink sticks.

water to dampen it, then begin to rub it on the flat surface of the ink stone. (The amount of water depends upon how much ink you expect to need. Begin with about half a teaspoonful, then experience will help you to increase or decrease this.)

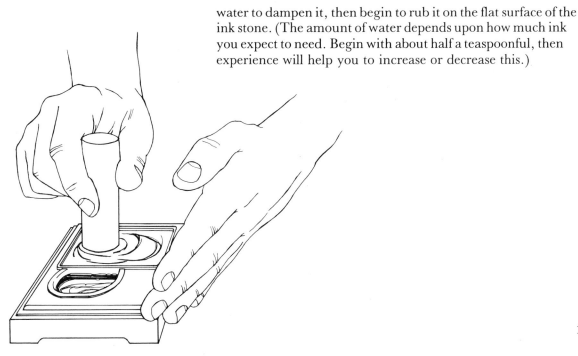

15

Rub the ink stick strongly on the stone in clockwise circles until the ink is thick and oily. When the rubbing motion seems to adhere, moisten the end of the stick again with water, or add an extra miniscule from a water dropper or tiny spoon. The ink is ready for use when it reaches an almost oily consistency, leaving trails behind on the stone's surface. By that time the rather abrasive noise of the grinding has become muffled and softer. As the water gradually evaporates, the mixture becomes slowly more concentrated.

Caring for the Ink Stick and Ink Stone

The ink stick should not be left to stand on the ink stone, or it will stick to it and damage the stone, therefore allow it to dry freely in the air. Old ink should not be left to dry and coagulate on the stone, as the gritty grains can spoil newly rubbed ink if they become mixed together. Gentle washing will keep the stone's surface clean.

The Painting Surface

With all the tools now assembled, the paper must be selected and then all the 'four treasures of the studio' will be ready and painting can begin. Chinese paper is available in many qualities and kinds. It was originally made from the bark of trees and old fishing nets, but is now made from rice-straw, reeds, wood pulp, etc. Some papers are sized and treated with glue, others are not. Altogether there are many types of paper with different levels of absorbency.

This absorbency is an essential quality of the paper. Individual papers – rice paper, mulberry or bamboo – react differently to the brush strokes, so the painting surface can have a determining effect on the style of the painting. The technique of the brush stroke is affected by whether the paper surface is rough, smooth, dull or glossy, more or less absorbent, so the techniques required may include a quicker brush stroke, a drier brush than usual, greater control of the ink, thicker brushwork and a more all-over style.

Sized paper allows for slower brushwork, as the ink does not run so quickly and it is also fast drying. Therefore, fine, detailed work is easier to accomplish on this type of paper.

Practice enables the painter to find out exactly how the brush and ink react with each different paper's absorbency. Since there is still a considerable amount of individual work required in the making of Chinese papers, the same type of paper may react differently with each different batch supplied. Even the weather, be it dry or humid, can effect the reaction of ink on the paper surface.

The painting paper, however, must be placed horizontally on a flat surface and held down by thin, flat weights. Underneath

the Chinese paper, an absorbent layer, such as blotting paper or newspaper, is placed to take up any surplus ink.

Paper Thickness

Painting paper does vary considerably in thickness. The levels of absorbency are not directly proportional to the thickness of each of the different kinds of paper, since the weave of the paper, whether it is open or closed, helps to affect the flow of ink through the paper. A piece of cleansing tissue is 3/1000 inch thick while one sheet of Chinese absorbent paper measures 2/1000 inch and others vary up to as much as 12/1000 inch, this being the thick *Hosho* paper.

The most versatile paper is available in a long continuous roll, approximately 25 yards (22 m) long. The most commonly used width is $17\frac{1}{2}$ inches (44 cm) wide, although narrower rolls are also obtainable, some of them already divided into fixed lengths.

Usually Chinese paper has a 'smooth' and a 'rough' side which can easily be discovered by finger touch. The 'smooth' side is the correct one to use as the painting surface. The rolls of paper all have this smooth side as the *inside* surface of the roll, presumably as a way of giving it the maximum possible protection.

Various types of silk can also be used as a painting surface, but the best quality work in shades of black is always done on paper as the essence of ink painting is the reaction between the absorbency of the paper and the brush.

Holding the Brush

The adaptability of the Chinese brush is very much a result of the way in which it is held. The techniques are as dependent upon this as the sword stroke is to the manner of holding the sword. The brush is not held close to the bristles, but in the middle or at the top of the handle, depending upon the stroke being executed at the time. The hand should be unsupported and be able to move freely. In ancient times the grip was not exactly the same as it is now. One book describes the moving of the ring and little fingers from the front to the underside of the brush as being as decisive a moment as the adoption of the stirrup in warfare. A totally different method was invented which gave incredibly

17

more control to the movement of the brush and therefore produced a whole new range of painting.

The brush is held perpendicularly between thumb and index finger, with the middle finger also touching the brush behind and below the index finger. The ring finger supports the brush from the other side and the little finger supports the ring finger. It is this combination of support from both sides that enables the artist to move the brush freely in all directions over the *flat* painting surface and still retain control over the movements of the brush.

The placement of the fingers is very similar to the method of holding chopsticks, but with a gentle touch capable of changing the pressure on the brush or the direction of movement instantly and without rearrangement of the grip.

The brush can be held vertically or obliquely, but in all cases the grip remains the same. It is not an easy position to take, especially for those who have already had experience with Western brush techniques, but it is essential to correct handling of the brush in all its manifest and diverse facets.

The upright brush position, although it can only produce a line, can give a variable thickness according to the pressure which is put on it at the time of painting. If only the tip touches the paper lightly, the stroke will be a thin one; if pressure is applied, the stroke is broadened because of the extra bristles used. The tone will depend on the ink loading of the bristles further up the tip.

In the *oblique position,* the brush tip and the upper bristles move parallel to each other and their paths are separate so that quite a different effect is achieved.

Effect is not only related to position and pressure, but also to the speed of the stroke. In the main, the broad stroke can be made at a slower pace than the thin stroke.

The essence of Chinese Painting is contained within brush control. The skills involved come only with practice; with continuous involvement and increased concentration, an instinct develops which guides the brush into appropriate positions and enables the hand to apply correct pressures, thereby achieving the desired results.

Mixing Shades of Black

For more control over the shades it is necessary to mix the black ink deliberately into the shades rather than acquire them casually mixed together in the brush.

1 Using the brush, take some of the dark ink from the ink stone and put it onto the plate or porcelain dish. (The brush should be wet, but not dripping.)

2 Using the same brush, take water, a few drops at a time, from the water holder to the plate and mix the water and ink together.

3 Test the resulting tone on a practice piece of paper. (Eventually this should not be necessary as experience will be the guide.)

4 If the tone is too dark, add some more water; if too light, then more ink is needed from the ink stone.

5 Black ink should always be used directly from the ink stone, but care must be taken that the brush is not too wet when this is done or it will automatically be watered down and reduced in tone.

6 When the shade, or shades, required have been made on the plate and the brush is to be loaded for the stroke, make sure once again that the brush is not already overloaded with water.

It is essential to be able to control the amount of water in the brush. Over a period of time and practice, a 'feel' is acquired as to the capacity of each individual brush to hold the ink, what the tone is when looking at the colour of the brush, and when re-loading is necessary because the brush has become too dry. Eventually, seven differentiated shades of black can be made, but for the beginner, five shades can be easily obtained from the black ink-stick. The diagram shows these shades, so that they can be referred to in later chapters.

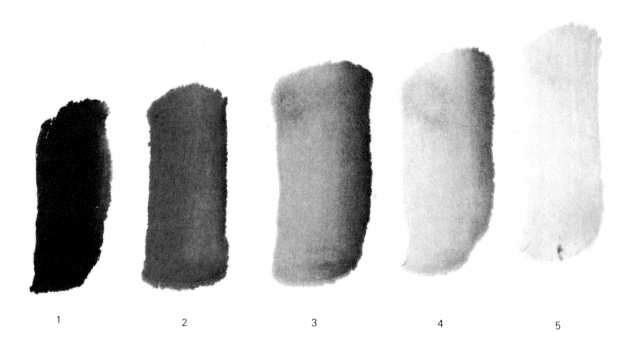

1 2 3 4 5

Loading the Brush

The capacity of the Chinese brush to hold water and ink is one of its most important features. Strokes can only be executed correctly and with control if the brush has been correctly loaded. The amount of water in the brush controls the wetness of the stroke. If the intention is to paint a brush stroke which flows freely over the surface of the paper, but is still within the painter's control, then it is not only important for the brush not

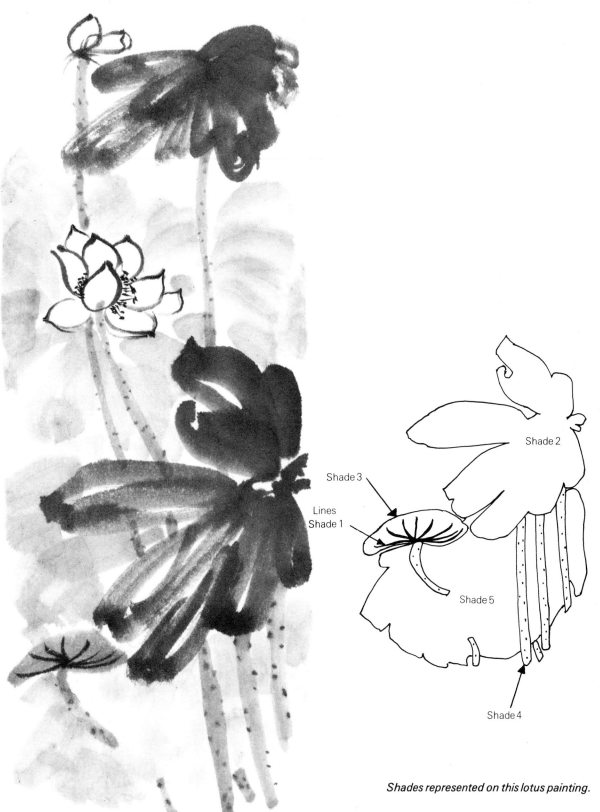

Shade 2

Shade 3

Lines
Shade 1

Shade 5

Shade 4

Shades represented on this lotus painting.

to be too wet, (which can cause over-absorbency in the paper), but also for it not to be too dry (which stops the brush flow and causes spaces to appear in the brush stroke).

Loading the brush with three tones. As an experiment in brush loading and a demonstration of the versatility of the Chinese brush, the following is a helpful exercise. First, make some black ink. Then:

1. Dip the brush in fresh, clean water.
2. Hold the brush upright to allow the surplus water to drip off.
3. Touch the tip of the brush to the darkest ink on the ink stone.
4. Allow the ink to rise up the bristles.
5. Press the bristles gently against the side of a clean plate or porcelain dish.
6. Touch the tip once again to the dark ink on the stone.

There should now be three tones on the brush; the darkest at the tip and the lightest tone nearest to the handle of the brush.

Now, put the whole of the brush bristles gently down on the Chinese paper and paint a line perpendicular to the handle of the brush. This oblique stroke should show all three tones on the paper.

If the heel of the brush (nearest the handle) is lifted off the paper, then only two tones will remain on view.

This exercise also helps to show that the angle of the handle controls both the width of the stroke and the tones. If the brush is held upright, for instance, then only one tone will result. The ink put on the tip can, of course, be varied, but the tip of the brush, which can only draw a line, can only give one shade. However, with all the bristles on the paper a much wider range of tonal changes can be achieved.

Even using only one tone, quite different effects are obtained by

a) using a wet brush, or

b) using a dry brush

It is not necessary to restrict practice to strokes alone. In fact it is more helpful to attempt small, but complete paintings, so that the individual strokes can be seen to combine with others in the overall composition of the brushwork.

The following chapters will demonstrate just a few of the ways that Chinese black ink together with a Chinese brush, can convey a myriad colours in the changing pageant of nature's beauty.

Bamboo

The bamboo grows as high as a tree and belongs to the same family as grass. Its stems – hard, straight and hollow – are always pointing upwards. Its leaves are green at all seasons and beautiful under all conditions – struggling beneath the winter snow or swaying with the storm, under the moon or in the sun.

Although bamboo is distributed throughout the sub tropical and mild temperate zones, the heaviest concentration and largest number of species is to be found in South-East Asia. There are about 1,000 species of bamboo, some growing to heights of between 100 and 120 feet and having stems up to 12 inches in diameter.

Bamboo has always played a key role in Chinese culture and art and has helped generally to shape the country's life style. Poets and painters are inspired by bamboo's beauty and strength. Su Shih said, 'I would rather eat no meat than live without bamboo. The lack of meat will make me thin, but the lack of bamboo will make me vulgar.' During the Southern and Northern Dynasties, a group of seven men of letters were known as the Seven Wise Men of the Bamboo Grove, so wisdom came to be associated with bamboo. As the bamboo grows upright, weathering all conditions, so it came to represent the perfect gentleman who always remains loyal. Wen Cheng-ming wrote:

A pure person is like a tall bamboo;
A thin bamboo is like a noble man

If any one subject area could be said to epitomise Chinese Painting and in particular shades of black, then it would certainly be bamboo. The structure of bamboo is allied in many ways to the strokes required in Chinese writing. When painting there can be no hesitation as brush meets paper, since the power that propels the brush to action comes entirely from within. Tranquillity combined with confident brush control is needed to achieve a successful bamboo painting.

Because of the popularity of the subject matter, a great deal has been written about bamboo painting. The following is a compact version of the principles involved in this specific area of Chinese brush painting, where composition, brush control and ink tones are all essential elements of a successful bamboo painting.

Principles of Bamboo Painting – Composition

Bamboo is made up of *four* parts: the stem, the knot or joint, the branches and the leaves.

The Stems

1. Space should be left between the sections of the stem for the knots.
2. The sections between knots near the ends of the stems should be short, those forming the middle should be long, while at the base of the stem they are again short.
3. Avoid painting bamboo stems that appear withered, swollen, or too dark in tone.
4. The stems should not all be of the same height.
5. The edges of the stem should be distinct.
6. The knots should firmly join the sections above and below them, their forms being like half a circle.
7. At about the fifth knot above the soil, the branches and foliage begin to grow.
8. If only one or two stems of bamboo are being painted, the ink tones can all be the same.
9. If there are three or more stems, then those in the foreground should be painted in dark tones and those in the back in light tones.

10. Avoid: a) swollen or distorted stems; b) uneven ink tones; c) a dryness that looks like decay; d) coarseness of texture; e) a density of ink that may look like rot and f) equal spacing between knots.

Knots

1 The upper part of the knot should cover the lower, the lower part should support the upper.
2 Knots should not be too large or too small.
3 Knots should not be of equal size.
4 They should not be too curved.
5 The space between them should not be too large.

Branches

1 There are thick branches and thin branches growing from the main stems.
2 Thick branches have thin branches growing from the knots and are really a smaller version of the main bamboo stem.
3 Branches grow alternately from the knots of the stems and cannot grow from any other part of the bamboo plant.
4 In landscape painting, the bamboo is so thin that the branches look like stalks of grass.

Leaves

1 In painting leaves the brush should be saturated with ink.
2 The brush strokes should move easily and without hesitation.
3 The stroke requires a movement which is in turn light and then heavy.
4 If there are many leaves they should not be tangled.
5 If there are only a few leaves, then the branches should fill the blank spaces.
6 When bamboos are painted in the wind, their stems are stretched taut and the leaves give an impression of disorder.
7 Bamboos bend in the rain, but remain straight in fair weather.
8 In fair weather bamboo leaves compose themselves near a strong forked branch, with small leaves at the tip of the branches and groups of larger leaves near the base or body of the plant.

Five essentials for good bamboo painting

1 The silk or paper should be of good quality.
2 The ink should be fresh.
3 The brush should be swift and sure.
4 Before starting the composition should be clear in the mind, with each leaf and each branch mentally fixed in position.

5 All four sides of the bamboo should be considered when
 planning the composition.

Errors to avoid
 1 Avoid making stems like drumsticks.
 2 Avoid making joints of equal length.
 3 Avoid lining up the bamboos like a fence.
 4 Avoid placing the leaves all to one side.
 5 Avoid making the leaves like the fingers of an outstretched
 hand or the criss-crossing of a net, or like the leaves of a
 willow.

How to paint bamboo – Technique
The Stems

 1 Make a *push stroke* from the bottom upwards.
 2 The amount of bristle on the paper indicates the stem
 width, up to a maximum of the total length of the bristle.

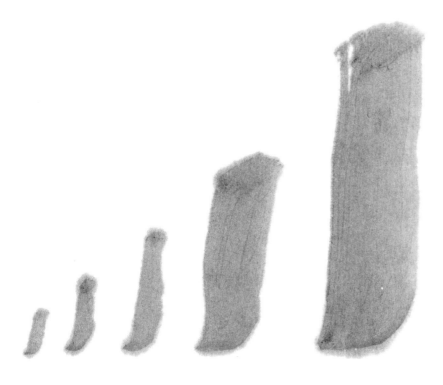

 3 With *light brush pressure,* place the brush on the paper and
 pause, push, pause, off.
 4 The brush handle should be vertical.

Upright brush

Stop. Pause and lift brush

Push

Pause

Thick bamboo stroke.

Less pressure gives
a narrower stroke

Thin bamboo stroke.

5 Leave a small space between the sections of the
bamboo stem.

6 Double brush loading can be used to put a shadow directly
 on to the stem, as it is not possible to overpaint.

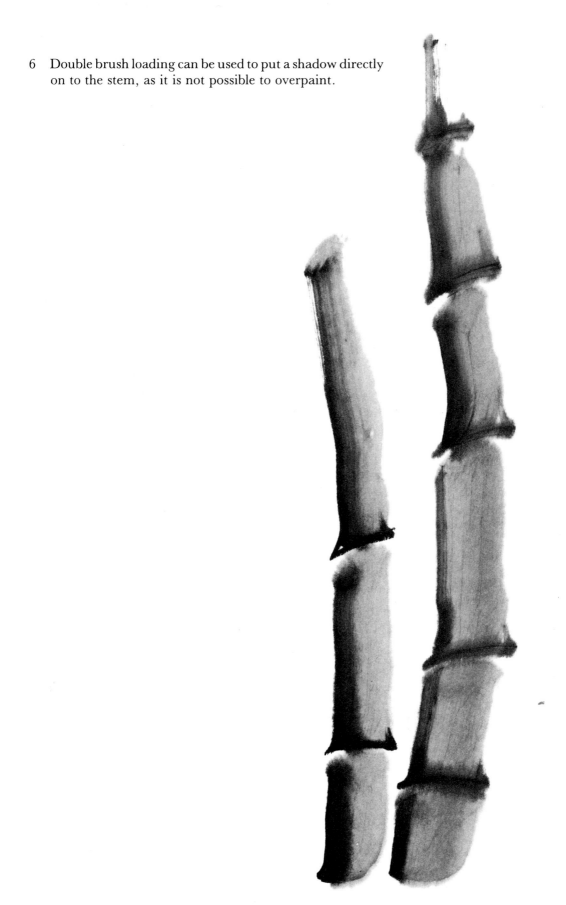

The knots or joints which divide the stem, should be added in ink which is one shade darker than the stem itself. They should be added before the stem is dry. There are two methods of adding *joint strokes:*

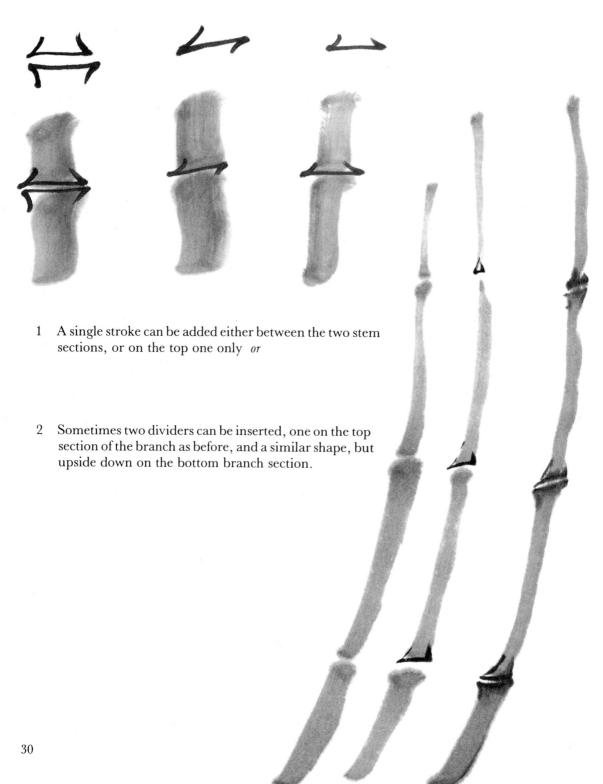

1 A single stroke can be added either between the two stem sections, or on the top one only *or*

2 Sometimes two dividers can be inserted, one on the top section of the branch as before, and a similar shape, but upside down on the bottom branch section.

The Branches

There are different thicknesses of branches as there are of stems.

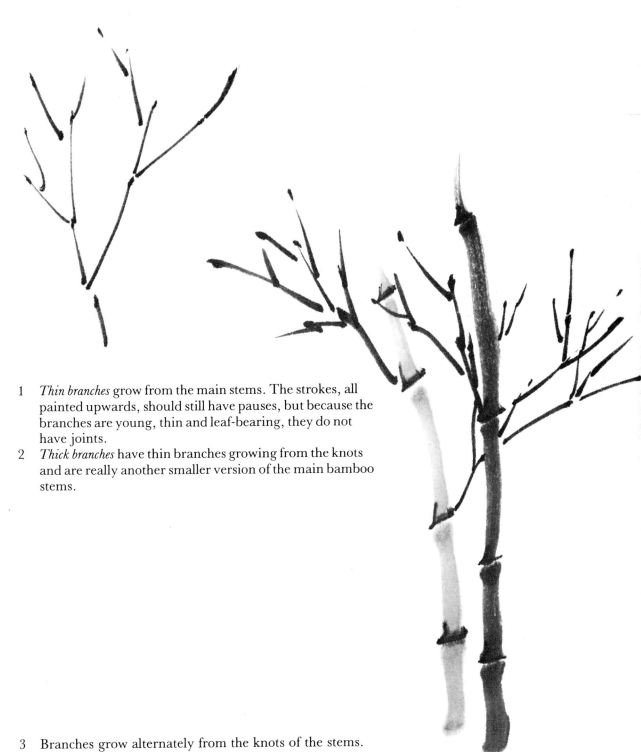

1 *Thin branches* grow from the main stems. The strokes, all painted upwards, should still have pauses, but because the branches are young, thin and leaf-bearing, they do not have joints.

2 *Thick branches* have thin branches growing from the knots and are really another smaller version of the main bamboo stems.

3 Branches grow alternately from the knots of the stems.

The Leaves

The leaves are always the last part of the bamboo plant to be painted and are the most difficult part of the composition. The groupings of the leaves can so easily appear clumsy, or overcrowded, that it is advisable to practise leaf combinations on their own before attempting to add them to the stems and branches of the final bamboo composition.

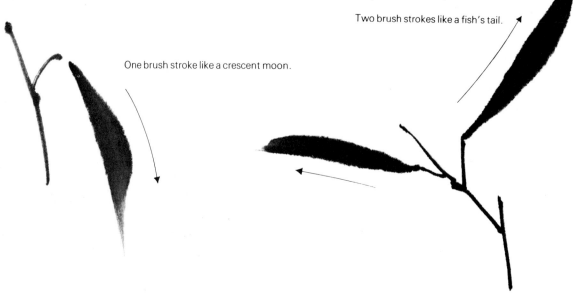

One brush stroke like a crescent moon.

Two brush strokes like a fish's tail.

1 Practise the different leaf positions first, beginning with small numbers of leaves.

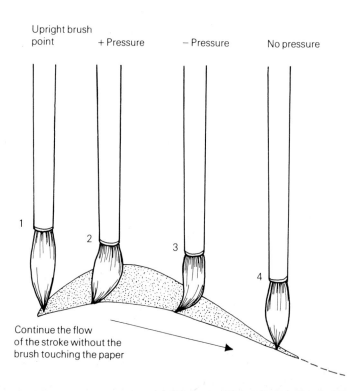

Upright brush point + Pressure − Pressure No pressure

Continue the flow of the stroke without the brush touching the paper

2 Leaves can be painted upwards, or hanging down, depending on the general disposition of the main bamboo composition. Usually small groups tend to have all the leaves painted in the same direction.

3 If the leaves overlap, then care must be taken not to overload the brush as two layers of ink are filling the same paper space. It is often easier to allow one group of leaves to dry before painting others on top of them.

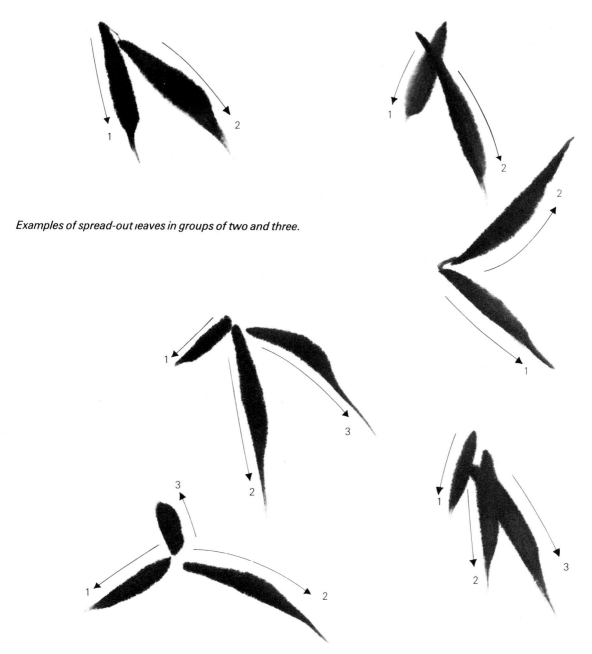

Examples of spread-out leaves in groups of two and three.

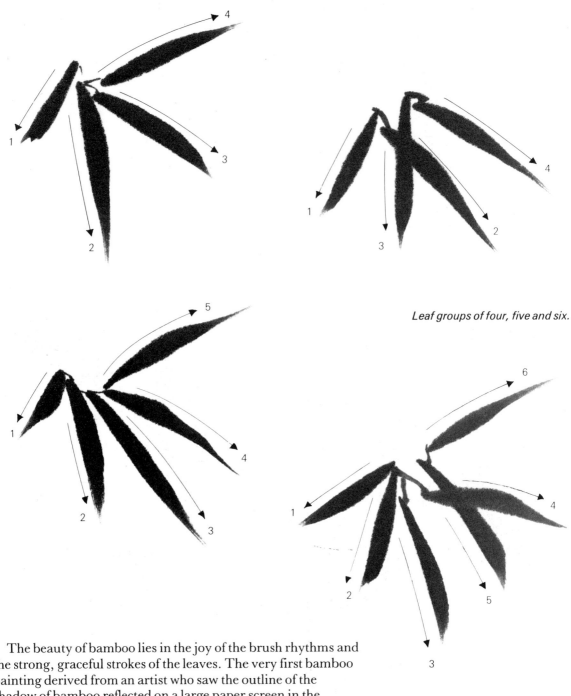

Leaf groups of four, five and six.

The beauty of bamboo lies in the joy of the brush rhythms and the strong, graceful strokes of the leaves. The very first bamboo painting derived from an artist who saw the outline of the shadow of bamboo reflected on a large paper screen in the emperor's palace. That is why the paintings always tend to be in strong single tones with each stroke having a clear-cut edge.

Bamboo is very difficult to paint but, by starting with small groups and not being frightened to throw away the failures, success will eventually be achieved; it will be appreciated all the more for the difficulties gone through in the path to its attainment.

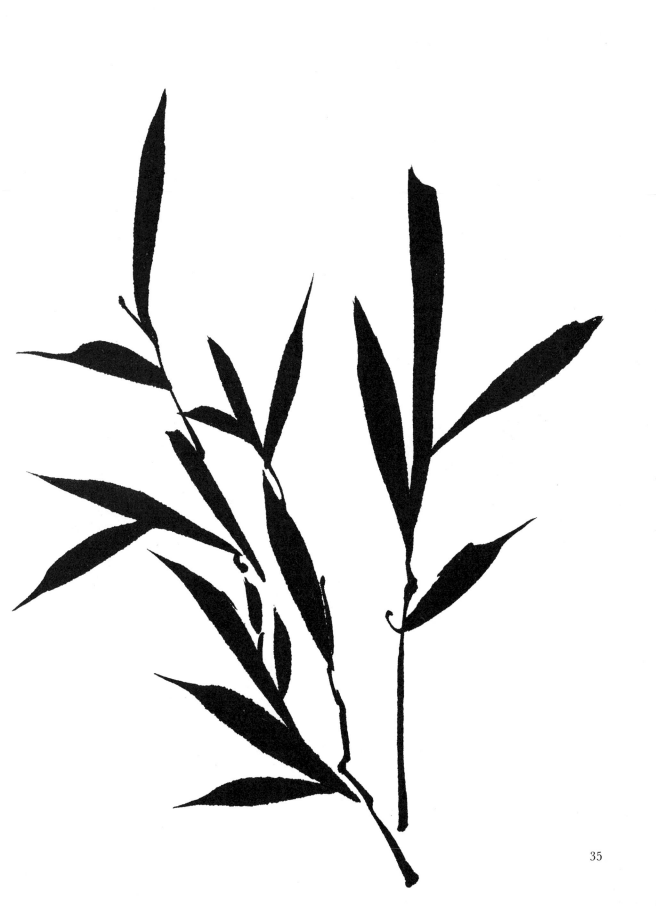

Calligraphy

The term calligraphy derives from the Greek work 'kalligraphia' which means beautiful writing. For the Chinese, the same high standards of brushwork apply to this art as apply to painting, for calligraphy is an art form in itself.

Bone Carving Shang Dynasty (1766-1122 BC)	Large Seal Chou Dynasty (1122-256 BC)	Small Seal Ch'in Dynasty (221-207 BC)	Clerical Style Han Dynasty (207 BC-AD 588)	Standard Sui Dynasty (AD 588-present)

Three hills or rocks

Shan Mountain

The branches, trunk and roots

Mu Tree

First, head and arms, later, legs only

Jen Man

Stream with eddies on either side

Shai Water

A picture of the sun

Jih Sun, day

Bone Carving
Shang Dynasty
(1766-1122 BC)

Large Seal
Chou Dynasty
(1122-256 BC)

Small Seal
Ch'in Dynasty
(221-207 BC)

Clerical Style
Han Dynasty
(207 BC-AD 588)

Standard
Sui Dynasty
(AD 588-present)

Head, scales and tail Yu Fish

 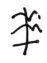 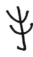 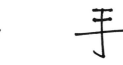

Fingers and lines of the hand Shon Hand

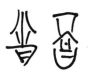

An ancient vase containing wine Yu New wine

The connection between the art of writing Chinese characters and the art of painting is easier to understand when you consider that these characters were, at one time, actually pictures. The earliest mode of written communication was in the form of pictographs rather like the Egyptian hieroglyphics. When a more complex system of combining pictures evolved, it became ever more necessary to condense the pictorial forms into symbols or characters, where each one stood for a particular word.

The historical evolution of the written language explains the variety of styles found during the different dynasties. The earliest pictographs were found carved on bones and shells and were from the Shang Dynasty (1766-1122 BC). A more formalised large seal script developed during the Chou Dynasty (1122-256 BC) and was inscribed in bronze and stone. During the Ch'in Dynasty (221-207 BC) the small seal style, which is still used in seals today, was introduced by the calligrapher Li Ssu. Then followed the more formalised official style, sometimes called 'clerical', in use from the Han Dynasty (207 BC-AD 220) to the beginning of the Sui Dynasty (AD 588).

Within the period AD 588 to the present day, there have developed three types of writing which are used appropriately to their context:

Running Standard Grass Symbols for 'moon' in three styles.

To be able to write some Chinese characters on a painting – the date or a good luck symbol, or perhaps a small poem – is the easiest way to begin to attempt Chinese calligraphy. Later it may be possible to make the calligraphy the whole focus and main element of the composition but, of course, it is always very difficult to write with confidence in a foreign language.

The importance of Calligraphy in Chinese life cannot be underestimated. Scrolls of calligraphy are traditionally offered as gifts and they are used as wall-hangings, hand scrolls and album leaves in the same manner as paintings. The two arts share a common origin and each evolved as a means of making an aesthetic statement, expressing the underlying principles of nature.

The Chinese characters, the written symbols of the Chinese language, are usually made up of several parts. Each part of the character is called 'a component'. (Some 'components' are characters in their own right.) Each component is composed of a number of basic strokes and the following are the seven most elementary ones. The arrows show the direction of the brush movement:

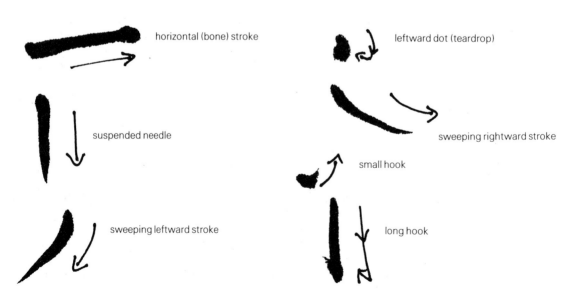

horizontal (bone) stroke

leftward dot (teardrop)

suspended needle

sweeping rightward stroke

small hook

sweeping leftward stroke

long hook

The main strokes involved in Calligraphy

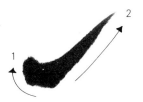

Hook stroke

Angle the brush handle away from yourself at approximately 45°. Point the brush tip to the top left corner of the paper. Put brush to paper, then drag from left to upper right, gradually lifting off.

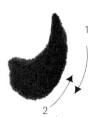

Teardrop stroke

Hold the brush vertically, press quickly to lower right, pause and rotate.

Bone Stroke

This stroke is the Hook and Teardrop combined, but lengthened in between.

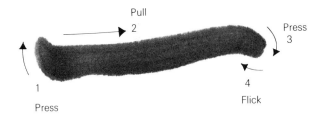

The basic structure of each character is balanced and logical and each stroke follows the other in a precise and rhythmic order. The general rule is to work from the top down, and from left to right within each character. The successive characters are placed in vertical rows, starting at the top of the paper and at the right hand side. Each new row begins at the top and is placed to the left of the previous one.

Although everyday Chinese writing is now done horizontally, it is still eminently acceptable for poems, couplets or decorative writing on paintings, to retain the old format of vertical lines.

The individual strokes already described should be practised first, with the painter sitting in a very erect position, or standing, if the work is to be particularly large. The brush should be kept upright and, to allow for totally free movement of the arm, the wrist should not be allowed to rest on the surface of the paper.

The ink used should be a rich, strong black. The brush loaded thoroughly but without being super-saturated. Remember to

increase the pressure to broaden the stroke and release it to obtain a narrower line. Try to develop graceful hooking strokes, carefree but strongly formed sweeping strokes and well-proportioned but self-contained long strokes. Boldness is required for the dots and short strokes.

As with all the Chinese brushwork, confidence has to be developed by practice. A bold, sure touch is a necessity for successful calligraphy. No possibility of erasing, altering or obliterating is available for the Chinese calligrapher, but constant practice using the brush will eventually develop the expertise required. Unlike other areas of Chinese painting, where individual stroke practice is not encouraged, calligraphy does need special attention to be paid to the basic strokes of the character component.

Developing from this, the quality of the brushwork is judged, not only by the length and thickness of the individual strokes, but also by how the strokes meet each other as they are written in sequence to form each character.

The rules of stroke order in writing Chinese characters are as follows:

Example	Stroke order	Rules
十	一 十	horizontal before vertical
大	ナ 大	left before right
夕夕	夕 夕夕	from top to bottom
你	亻 你	left component before right component
月	冂 月	from outside to inside
围	冂 用 围	inside precedes the sealing (closing) stroke
小	亅 小 小	middle precedes the two sides

Most of these rules and the basic stroke elements are contained within the much used character for 'long life'. This character, *shou* (pronounced show) is to be found as a single decorative piece of calligraphy on a scroll, as an embroidery motif, on pottery and contained within many written expressions of general goodwill on Chinese New Year cards. It can most usefully be tried as the first calligraphic painting motif, after the individual strokes have been practised.

Long life
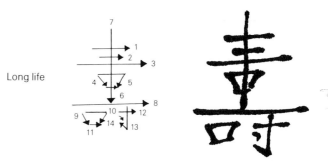

Follow the arrow directions and paint the strokes in the order as shown. It often helps to vary the size of the character to find which particular format suits you best for practice purposes.

Another popular character is 'luck' which is *Fu* (pronounced *foo*). Again, the arrows give both direction and order of stroke, so that the character will develop rhythmically as it is painted.

Luck
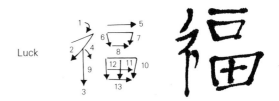

If one stroke does not quite join on to the next, it is much better to leave the slight gap, than to attempt to add an extra piece to the character, and of course, as always with traditional Chinese painting, strokes cannot be successfully 'tidied up' if the brush technique has caused an incorrect stroke to be formed. No amount of description can substitute for the marvellous feeling of accomplishment when, after many faulty practice pieces, one character, or even one stroke, appears faultlessly on the absorbent painting surface.

Happiness
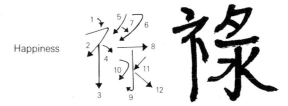

The addition of the character for 'happiness' to the two already described, will enable the painter to write 'All Good Wishes – luck, happiness and long life.

All good wishes.

Another small but useful series of characters are the set of Chinese numbers, plus the characters for month and year necessary to enable the date to be written. A painting seems to be more finished if it is dated and the small number of characters necessary to achieve this are as follows.

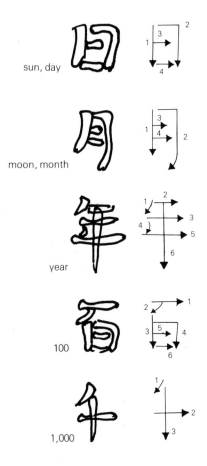

sun, day

moon, month

year

100

1,000

Line and arrow diagrams indicate order of painting and direction of brush.

一
二
三
四
五
六
七
八
九
十

one

two

three

four

five

six

seven

eight

nine

ten

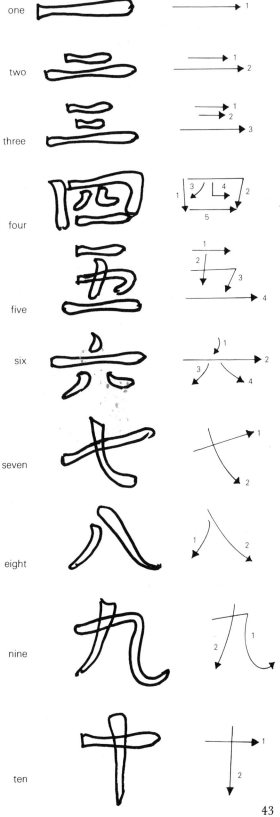

one	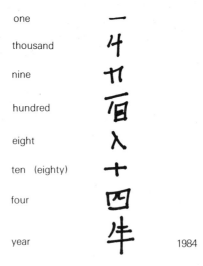	
thousand		
nine		
hundred		
eight		
ten (eighty)		
four		
year		1984

To begin with this may be suffic■nt, but if more accuracy and precision is required then the month and the day can be added.

comma	
five (fifth)	
month	
comma	
six (sixth)	
day	

Written characters in their pictorial form were the fore-runners of today's calligraphy and also of traditional painting. They appeared on bronze vessels and probably at about the same time as embroidery motifs, with particular attention being paid to the character of the silk cocoon. Chinese embroidery pieces have examples of Chinese script worked on them, from single characters to full length poems, producing designs rich in symbolism as well as pleasing aesthetically and intellectually. Since most ancient embroidery was made as an adornment for the robes of male officials, the longevity character – *shou* – appeared frequently, but the most popular character on old embroidered pieces was 'the double *hsi*' – double happiness:

One 'good wish phrase' also popular on embroidery, seems to sum up the far-ranging influence of calligraphy as an art form, embodying, as it does, a wealth of ancient philosophy in a minimum of writing. The seal character inscription shown reads 'Wu fu chin ju'. 'May you have the five blessings and embody the nine similarities (in your person)'. The 'five Blessings' are long life, wealth, health, many sons and a natural death. On the right is the modern form.

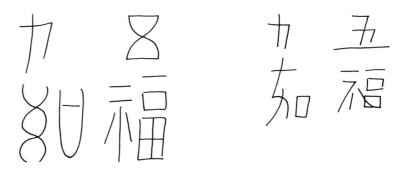

The 'nine similarities' are embodied in the following wish: 'Like high hills, like mountain masses, like top-most ridges, like huge bulks of rock, like streams, like the morn, like the sun, like the age of the southern hills and like the luxuriance of fir and cypress, so may be thy increase and descendants to come.'

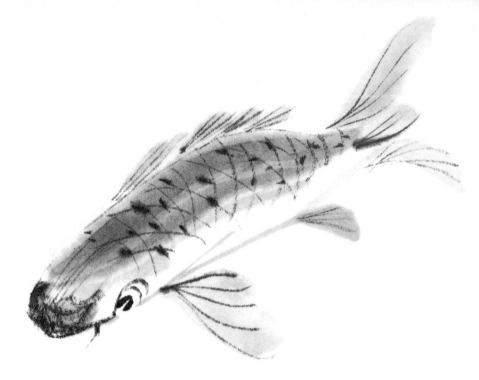

fish

The Chinese traditionally paint fish swimming in water. If an artist caught the twists and turns of fish swimming among the water weeds, then the painting would be most prized by connoisseurs.

The *carp* is the most frequently depicted fish in Chinese art and as it was believed that it could transform itself into a dragon by leaping the Lungmen Falls on the Yellow River, it was regarded as a symbol of literary eminence, or it was used to symbolise the passing of examinations with distinction. The carp appears on ceramic vases, in lapis-lazuli and jade carvings, as well as in many paintings. Because of its scaly armour, it is regarded as a symbol of martial attributes, and as it struggles against the current it is also a representative emblem of perseverance.

A pair of fish together are symbolic of marriage and of harmony, while groups of fish swimming gracefully with the waters' flow can be conceived as a visual demonstration of the Chinese way of thinking, figuring both in Taoist and Buddhist philosophy. The fish signifies freedom from restraints, moving easily through the water in any direction. The 'flow' of fish in water can be paralleled by man's existence in the ever-changing natural world.

Carp can live to 60 years' old and even up to 100. They are often kept as pets and can adjust to different water temperatures and climates. They are easily fed with vegetables, noodles or cooked rice.

Goldfish are well known for their bubbly eyes and pearly or metallic scales. There are 1,000 years of documented tradition in

China showing goldfish being kept and displayed in wide-topped ceramic bowls. Because of the way they were kept, they have eyes which look upwards, and decorations known as 'hoods' and curved fins which are only seen at their best from above.

The Chinese list 9 types of fish: carp, pompadour fish, mandarin fish, goldfish, freshwater goby, flying fish, small fish, shrimps or crayfish, crabs.

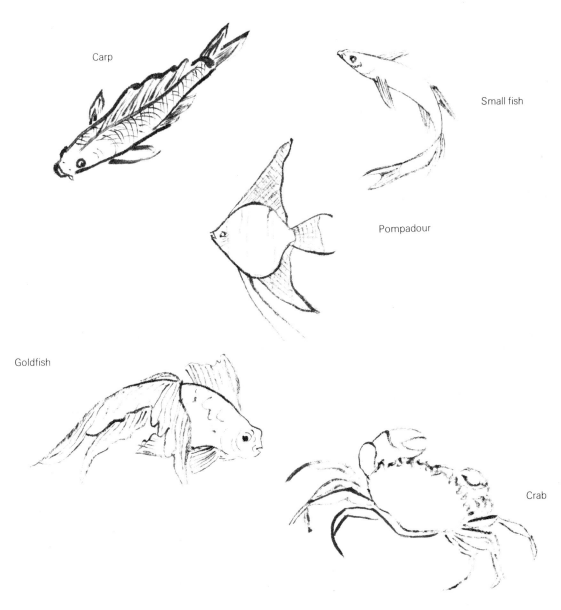

Some of the more common fish.

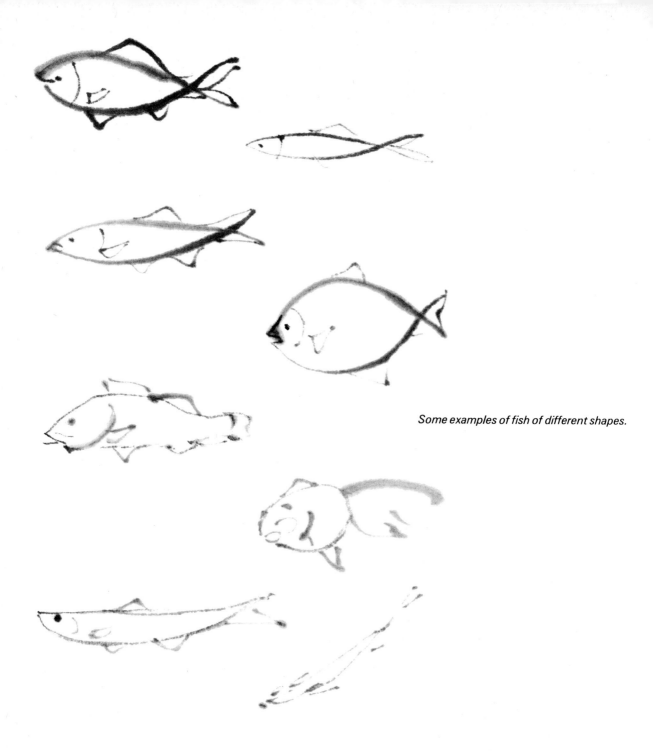

Some examples of fish of different shapes.

General Order for Painting Fish

Usually fish should be painted beginning with the head, then the body, and finally the tail.

As an overall, general description of the method, it is suggested that the head (mouth, eyes, gill covers) are first

painted in light, diluted ink (*stage 1*), and then thick dark ink used on the forehead and eyes, (*stage 2*). The body can be painted with a double-loaded brush tipped with black ink in bold brush strokes which suggest the light and shade of the body, (*stage 3*). Finally, in (*stage 4*), scales are added while the body stroke is still wet, and fins and tail, in medium ink, put the finishing touches to the fish.

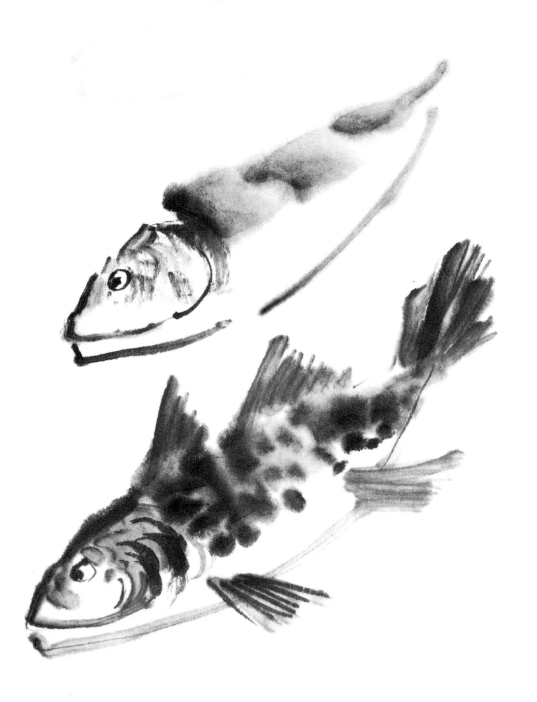

Painting Frogs

1 Eyes and mouth in black ink.
2 A wet stroke follows for the back.
3 Add four legs.
4 Add feet, three on each leg in darkish ink.
5 Lastly in paler ink add a line for the frog's underside.

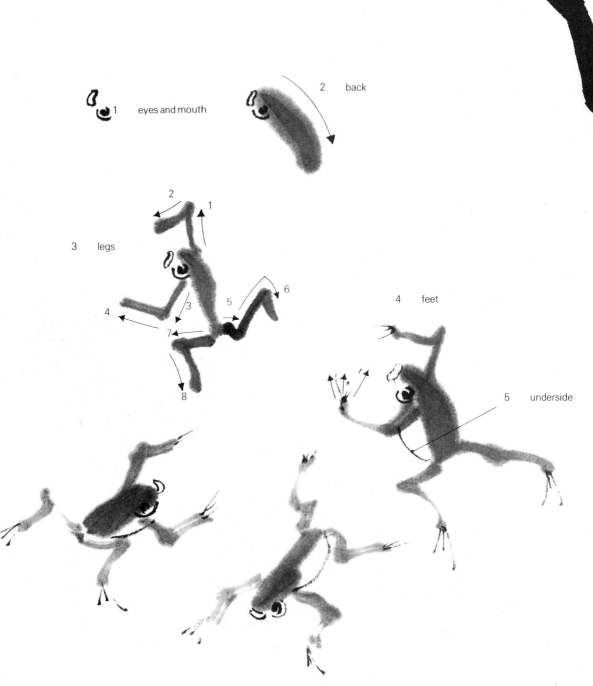

1 eyes and mouth

2 back

3 legs

4 feet

5 underside

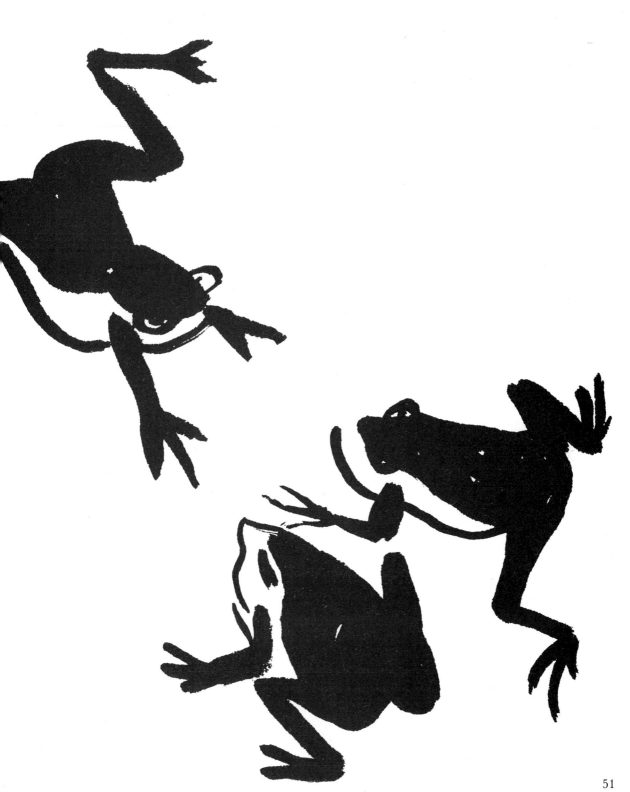

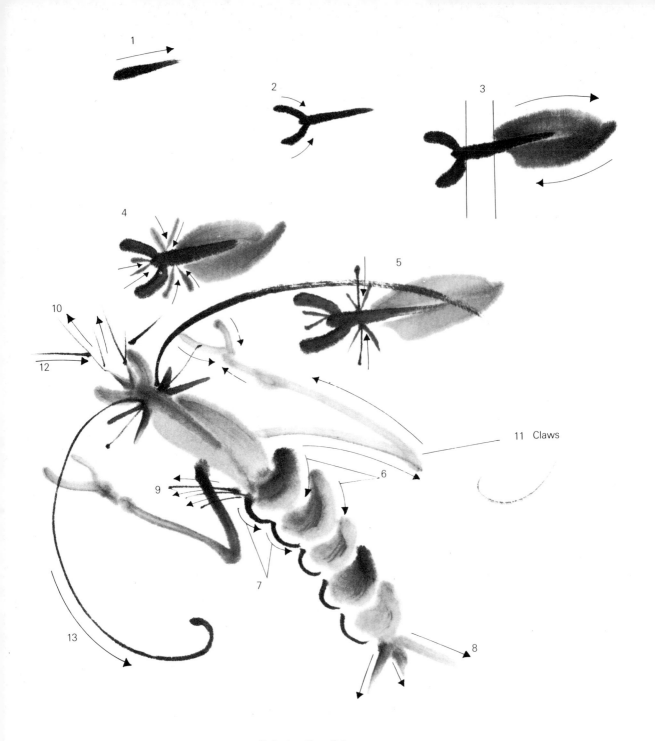

Painting Crayfish

1 Using dark ink, paint the main head stroke first.
2 The two fore parts of the head are next.
3 With a lighter shade paint the head as it joins the body.
4 Eyes and mouth parts in medium ink.
5 Eye stalks in black.

6 The five body segments are painted with a double loaded brush, lightening as the segments become smaller. The body can be bent into a flowing swimming position by the careful placement of the semi-circular strokes.
7 Outline the underneath of the segments.
8 Add legs.
9 Add tail.
10 Mouth parts.
11 The claws are painted next in dark grey using five very positive strokes.
12 With a fine brush and dark ink add the eyes.
13 Lastly the feelers, in a large sweeping stroke. Should the brush leave the paper in the course of making this stroke, the space between should not be filled in or any attempt made to join up the two parts of the stroke. The Chinese have an expression for this 'brush absent, spirit present', indicating that the mind knows that the stroke is continuous, even if it is not so in real terms.

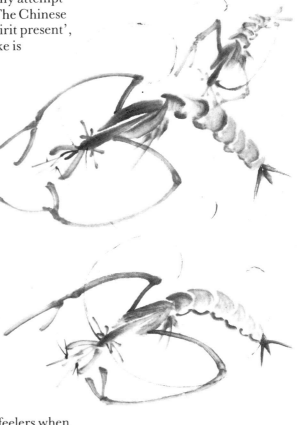

A fascinating decorative pattern is made by the feelers when several crayfish are painted in one composition. There is no need in Chinese painting to indicate the water by wavy lines – it is well understood that blank space in a composition with fish can only represent water. The other difficulty, always present for the Western artist who feels the need to fill up the paper, is to make sure that the composition contains plenty of space. Should there be any doubt in the mind about whether to add more, then the decision should always be *NO*. It is better to have less in the picture than an overcrowded painting.

Painting Goldfish

1 Body with two-colour wet stroke.
2 Eye semi-circles and under body line in dark grey.
3 Mouth and eyes in deep black.
4 Four side fins and tail in medium grey.
5 Thin black lines on fins and tail.

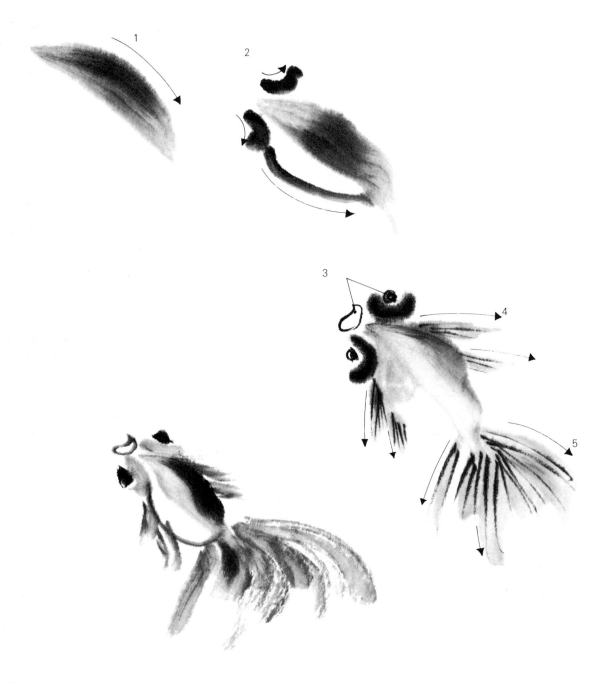

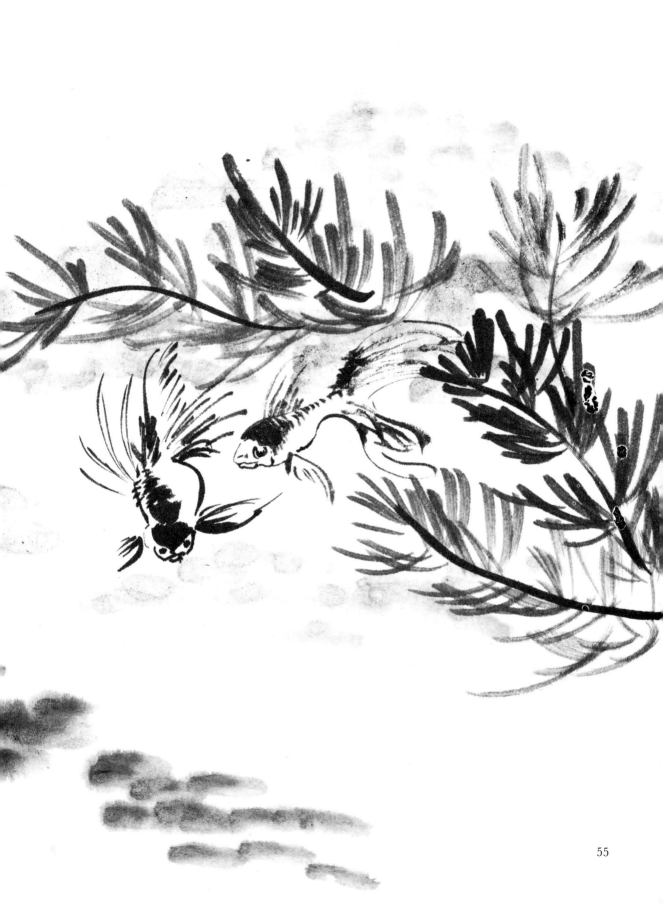

Painting Crabs

Usually the crab is painted in all one shade, though variations are possible. The order of painting is:

1 The three parts of the body first.
2 The legs next, four each side, each leg is in three parts.
3 The eyes are wet blobs, each with an eye stalk.

Although crayfish are often painted in a group being the sole elements of the composition, it is quite usual to see various water creatures together in one painting; sometimes crabs and small fish, sometimes large fish swimming around their smaller counterparts. Occasionally fish may be shown with a lotus flower, or frogs sitting on a lotus leaf, or on a river bank.

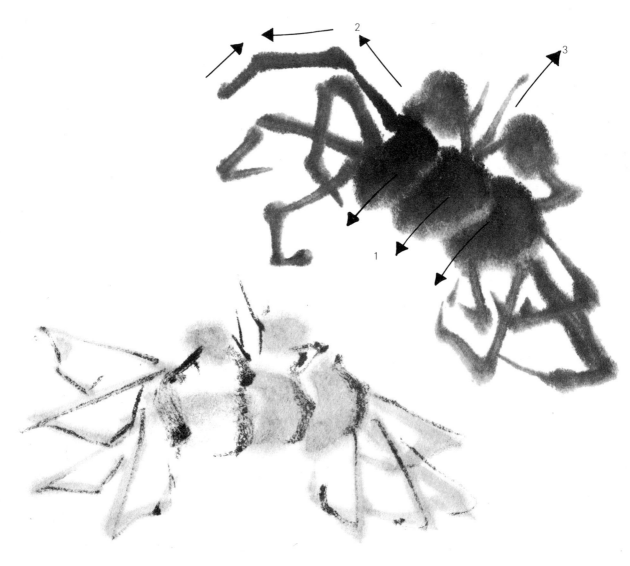

However, in all compositions in which fish are the main constituents there is always an element of movement implicit in the painting. As many Chinese paintings are rather static in concept, such compositions make a welcome change.

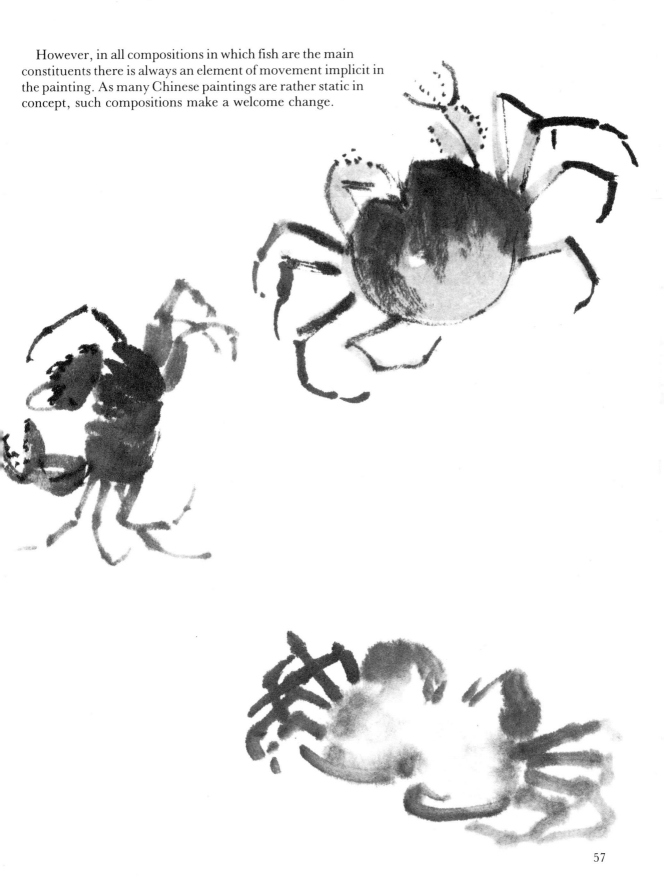

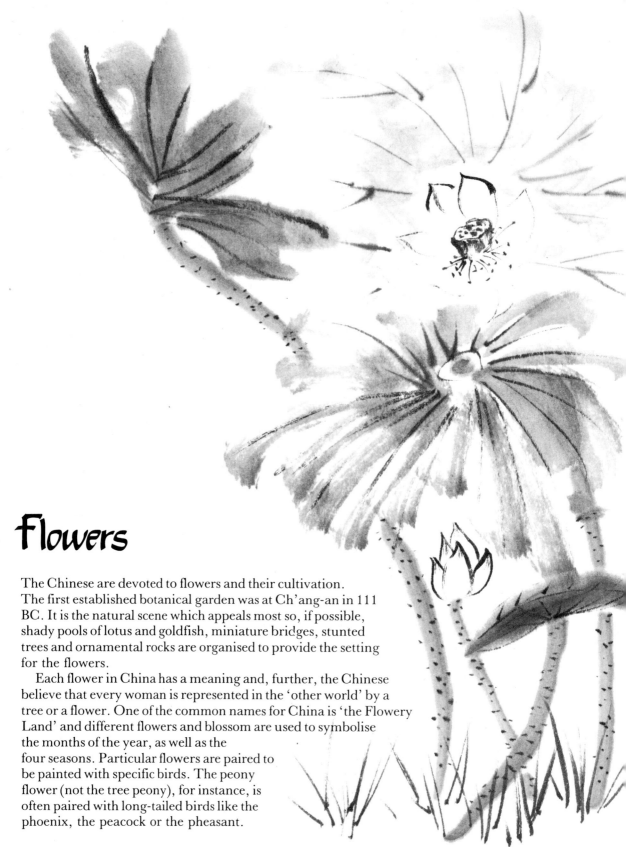

Flowers

The Chinese are devoted to flowers and their cultivation.
The first established botanical garden was at Ch'ang-an in 111
BC. It is the natural scene which appeals most so, if possible,
shady pools of lotus and goldfish, miniature bridges, stunted
trees and ornamental rocks are organised to provide the setting
for the flowers.

Each flower in China has a meaning and, further, the Chinese
believe that every woman is represented in the 'other world' by a
tree or a flower. One of the common names for China is 'the Flowery
Land' and different flowers and blossom are used to symbolise
the months of the year, as well as the
four seasons. Particular flowers are paired to
be painted with specific birds. The peony
flower (not the tree peony), for instance, is
often paired with long-tailed birds like the
phoenix, the peacock or the pheasant.

The chart shows the symbolism and groupings of the different flowers and blossoms throughout the year.

Chinese Floral Calendar and Flower Symbolism

Flowers for the 12 Seasons	Seasons	Seasonal Flowers	Flowers Symbolising	Accompanying Animals / Designs	Secondary Characteristics
1 Prunus	Spring symbol: the Tree Peony	Almond	Womanly beauty	Court ladies	Fortitude in sorrow
		Bellflower	Happiness, good luck	God of wealth	Success/fame
2 Peach		Cherry	Womanly beauty, youth	Young people	Virility, hope
		Millet	Plenty, strength	Quails, partridge	Perennial effort
		Narcissus	Good fortune	Fairy beings.	Introspection, self-esteem
3 Peony		Peach	Spring, youth, marriage, immortality	Bride & attendants	Good wishes, riches
4 Cherry		Willow	Meekness, feminine grace, charm	Swallow	Poetic ability, artistic worth
5 Magnolia	Summer symbol: the Lotus	Aster	Beauty, charm	Butterflies	Humility
		Azalea	Womanly grace	Butterflies	Luxuriant abilities
		Camellia	Beauty, good health	Dragonflies	Physical & mental strength
6 Pome-granate		Convolvu-lus	Love & marriage	Humming birds	Early day, dependence
7 Lotus		Iris	Grace, affection	Bees	Beauty in solitude
		Jasmine	Grace, sweetness	Butterflies	Fragrance, attraction
		Lotus	Summer, purity, fruitfulness	Duck	Spiritual grace
8 Pear		Magnolia	Feminine beauty	Bees	Ostentation, self-esteem
		Peony	Love, beauty, spring, youth	Phoenix, peacock Pheasant	Royalty, pre-eminence
9 Mallow		Pome-granate	Posterity, offspring	Playing children	Natural abundance
		Rose	Fragrance, prosperity	Bees, humming birds	Sweetness in desolation
10 Chrysan-themum	Autumn symbol the Chrysan-themum	Chrysan-themum	Mid-autumn, joviality, ease	Crab, dragon, girls	Scholarship, retirement
		Gardenia	Feminine grace, subtlety	Swifts	Artistic merit
		Mallow	Quietude, rusticity	Martins, geese	Peace, humility
		Myrtle	Fame, success	God of wealth, officials	Humility in achievement
		Oleander	Beauty, grace	Birds, insects	Joy, achievement
		Olive	Grace, delicacy	Wild geese	Quiet persistence, strength
11 Gardenia		Pear	Purity, justice	Officials in robes	Unswerving judgement
12 Poppy	Winter symbols: Prunus and Poppy	Almond	Womanly beauty	Court ladies	Fortitude in Sorrow
		Fungi	Long life, immortality	Old man, young boys	Persistence
		Pine	Long life, courage	Stork	Immortality, faithfulness
		Plum	Winter, long life strength	Stork, white crane	Hardiness, triumph
		Poppy	Striking beauty, rest	White bear	Retirement, success

Painting Flowers

There is an accepted order for painting flowers the Chinese way. The flower heads themselves are painted first, then the leaves and lastly the stems. These rules have special exceptions in that grass orchids have their leaves painted first and blossom is not regarded as 'a flower' in the same way as, say, a lily or lotus. Most Chinese traditional artists begin by painting the most important element of the subject matter. It is, therefore, very realistic to consider that in the case of a plant this would be the flower itself; for blossom, it is the branch which is most dominant; and the elegance of a grass orchid is provided by the special overlapping of its long, thin leaves.

As there are basically two methods of painting – the outline method and the solid-stroke technique – a choice has to be made as to which of the two techniques to use for different flower compositions. Most flowers can be painted in either technique or a combination of the two methods. That is to say, there are three ways:

1 All outline.
2 Outline flowers and solid-stroke leaves.
3 All solid strokes.

Each of these alternatives produces a different emphasis in the completed painting. Flowers which are painted totally in outline may be described as 'light' in emphasis, as it is the brush point only which touches the paper. At the other extreme, when the flowers, leaves and stems are all painted in the solid-stroke technique, the composition has a stronger feeling to it, since much more of the brush head has been applied to the painting surface. Tradition has built up a series of accepted combinations for specific flowers, although there are certainly no rules governing the choices made.

Most outline technique flowers are painted in black, but the solid-stroke techniques are often more suitable to colour painting, except in the case of a very important and positive flower such as the lotus.

The Narcissus

To demonstrate the *outline technique,* a most suitable flower is the narcissus. The Shu-hsien, Water Immortal or narcissus is first mentioned in the 9th century as coming from Fu-lin, Byzantium. In late winter, when the Chinese celebrate the Spring Festival, they prepare feasts and decorate their houses with flowers and plants, their favourite for this purpose being the Narcissus. The delicate, narrow, emerald-green leaves, large white flowers, golden coronas and silvery-white roots provide an elegant background to the festivities and their delicate fragrance adds to the atmosphere.

The narcissus once grew wild along the marshes of the south-east coast of China becoming a cultivated flower in the 10th century. There are many varieties of narcissus, which divide into the single flowered category which has six petals, or the bunch-flowered variety which has a corona of split petals clustered in a ball-shape.

The Chinese believe that the colour, the fragrance and the elegance of this flower liken it to an ancient poem or painting.

Before beginning the painting, it is always important to organise the composition in the mind as fully as possible, while carefully rubbing the ink stick on the ink stone.

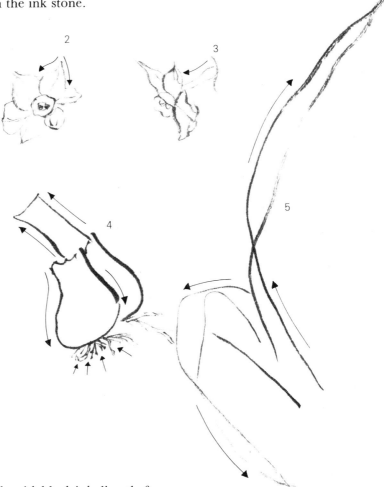

Painting the Narcissus

1 Load the tip of the brush only with black ink directly from the ink stone.
2 Beginning with the most central flower, paint its centre and then each petal starting from the inside of the flower.
3 Next, mix the black ink with some water on the palette and with dark grey paint the outline of the thicker section of the stem nearest to the flower.
4 Next the bulb is painted with its roots.
5 Finally, the long elegant leaves are painted in dark ink.

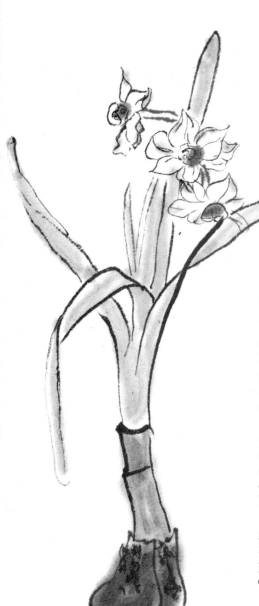

The composition, which clearly shows white flowers in their elegant simplicity, can be left as complete at this stage, or have shades of grey (or colour) added. The shades should not be added too carefully, as the intention is not merely to 'fill in the outline' but to add more depth to the painting; and care should be taken that all the outlines are dry before adding these shades. To demonstrate the alternative, the outline flower and solid-stroke leaf method of painting flowers, the best example is the Chinese lotus.

The Lotus

To the Chinese, the lotus is the most important of all the cultivated flowers, grown for both its beauty and its usefulness. It has large blossoms, tinted pink, creamy white or yellow, growing on stalks six or seven feet high, appearing from the centre of very broad, (sometimes three feet in diameter), nasturtium-shaped leaves.

Every part of this plant has a special use; the fruits and leaves are used as food; the dried yellow stamens are used as an astringent and as a cosmetic; the seeds can be used as medicine or eaten as a dessert. The kernels are boiled in soup, roasted or eaten raw, while the stems are sliced and boiled. The leaves can be taken medicinally or used dried to wrap food.

The lotus is also known as a symbol of purity and perfection, growing out of the mud into a state of blossoming beauty and fruitfulness. The flowers are open for a mere three days, then petal by petal they disintegrate, leaving the green seed head exposed.

It has become very positively connected to Buddhism, partly because of the symbolism; partly because of the visual representation of the Wheel of the Law by the flower form, with the petals taking the place of the spokes. Buddha is usually represented as seated on the sacred lotus and, in imitation of this, Buddhist priests have developed the 'lotus posture' – a cramped position which develops a state of bodily peace. The flower is also one of the 'eight treasures', said to be auspicious signs seen on the sole of Buddha's foot.

It is not only a symbol important to Buddhists, that the lotus is recognised, but also as an emblem of one of the Eight Immortals of Taoism – the other main Chinese religion. The seed-cup on the lotus stem, holding as it does many seeds, becomes an emblem of offspring.

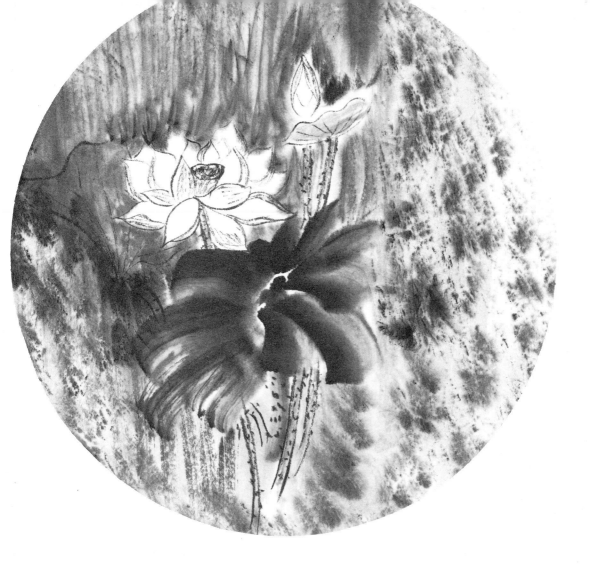

The lotus is also regarded as representing summer and fruitfulness; it appears in stylised form in paintings, in embroidery, on carpets and as ceramic decorations.

Although it is not an easy flower to paint, mainly because of the disproportionate size of the leaves and the fact that the Western painter may well never have seen a lotus bloom, it is the most important flower in Chinese traditional painting and as such is well demonstrated by the power and versatility of shades of black.

Painting the Lotus

1 Plan the composition so that spaces are left for crossing leaves and stems.
2 Paint the pod heads first by outlining the seed pod and the tiny circular seeds.

3 Seed pods on their own should have a space left at the base so that the stalks can be joined correctly.

4 If the seed pods are still surrounded by the petals of the flower, then the petals grow from the base of the pod and over-lapping must be planned before the outlines are painted.

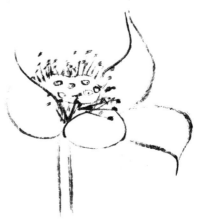

5 The flower petals are finely veined and, although it is not necessary to show them, light-toned, thin ink lines can be included.

6 The leaves can be shown in various stages and positions as
 they unfold.

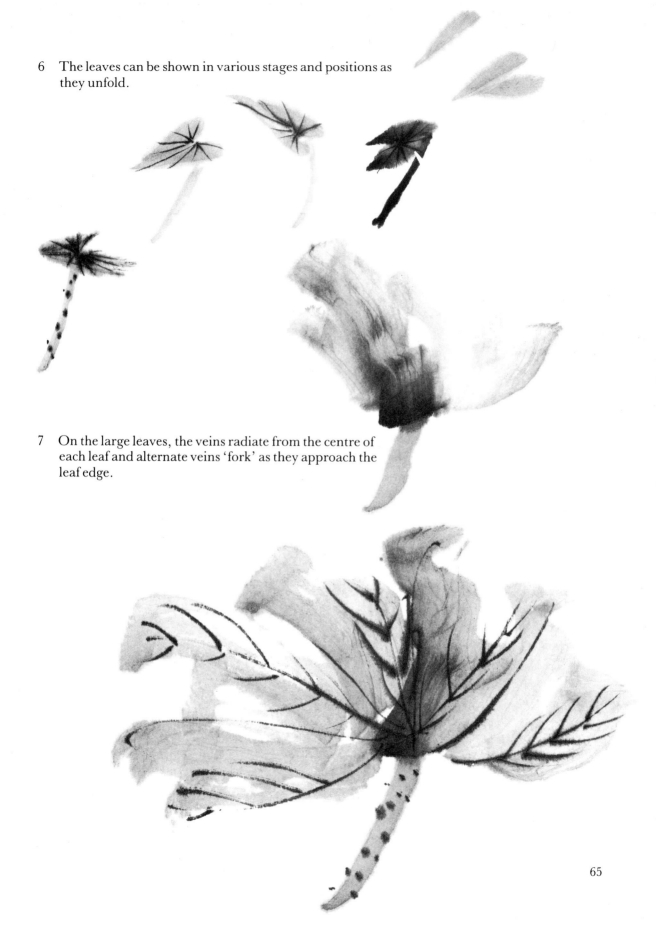

7 On the large leaves, the veins radiate from the centre of
 each leaf and alternate veins 'fork' as they approach the
 leaf edge.

8 The leaf stalks are darker than the flower stalks.

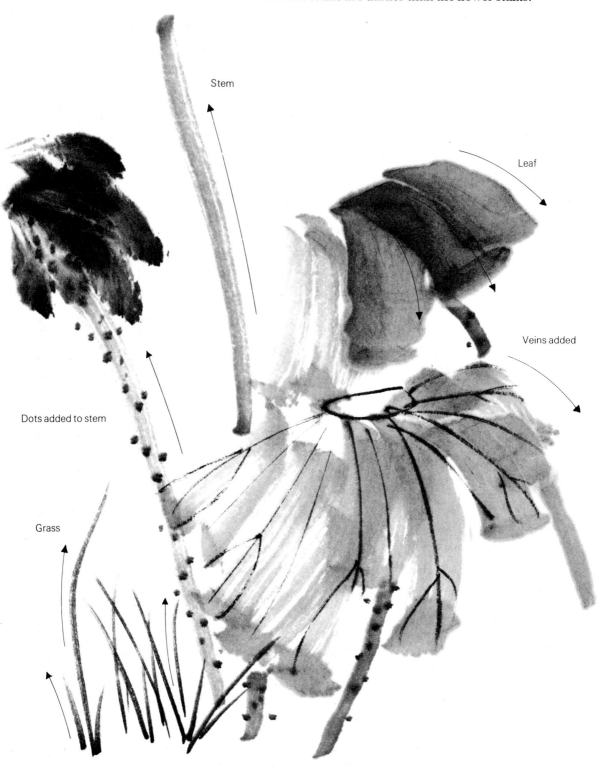

Stem

Leaf

Veins added

Dots added to stem

Grass

9 Each flower, bud and leaf has its own individual stalk.

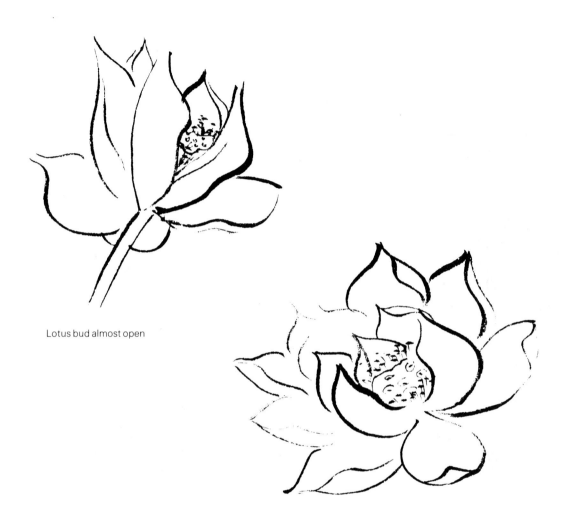

Lotus bud almost open

Fully open flower

The Peony

The tree-peony is regarded as the king of flowers, the flower of riches and honour and is held in high esteem by the Chinese since the T'ang Dynasty.

It is an emblem of love and affection, a symbol of feminine beauty, and also represents the season of spring. The peony is sometimes called the 'flower of wealth and rank'. From the Sung period onwards it has often been a favourite pottery motif, both on its own and in composition with rocks.

If the plant becomes loaded with flower heads and heavily leafed in green this is regarded as an omen of good fortune; but if the leaves dry up and the flowers suddenly fade, this presages poverty for the flower's owner, or even some appalling disaster to the whole family.

Flowering plants are divided into two kinds; those with woody stems, usually perennials, and herbaceous plants which are usually annuals.

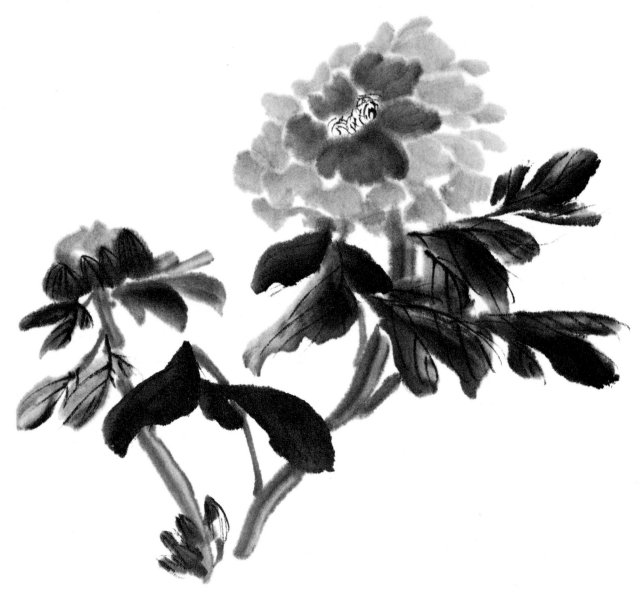

Painting the Peony

Following the painting of the narcissus as an all-outline flower, and the lotus, which was painted in the combined techniques of outline flower and solid-stroke leaves, the third technique is to

paint the flowers and leaves all in the solid-stroke method. The peony is a good example of this method as it lends itself to the impressionistic looseness of the brush strokes, in contrast to the carefully constructed neatness of outline flowers.

The flower itself is large and heavy, not delicate, and is well shown by the techniques of shades of black.

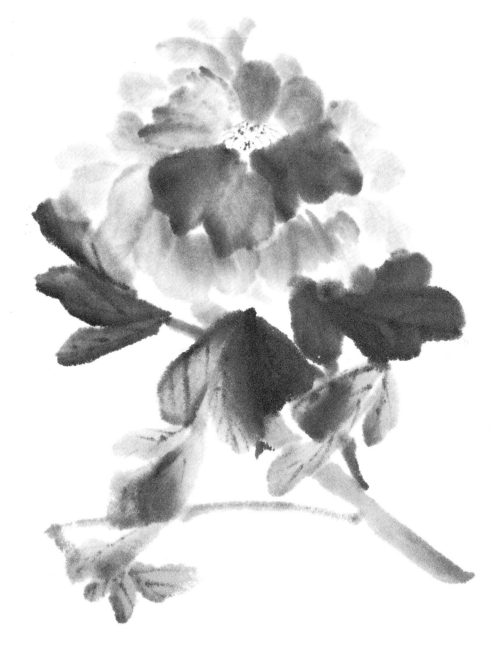

Peony flower heads are very heavy. Notice how closely the flowers grow to the leaves.

The order of painting for the peony is: flower first, followed by leaves, and finally the stems are added. It is usual to begin at the centre of the flower, whether the flower is fully open or half open. Petals can be painted in a light shade of grey first, with strokes being superimposed in darker shades while the first brush strokes are still wet. The peony has petals darker at the outside and lighter in the middle, with each petal having a very ragged edge. The peony plant has its leaves grouped in threes at the end of a stem which is connected to the main one.

Centre brush point.

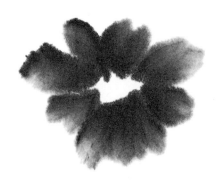

Brush point should always be to the centre.

Add another petal layer in a lighter tone.

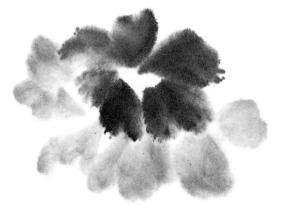

Add more petals to the top or bottom of the flower head, depending in which direction you wish the head to point.

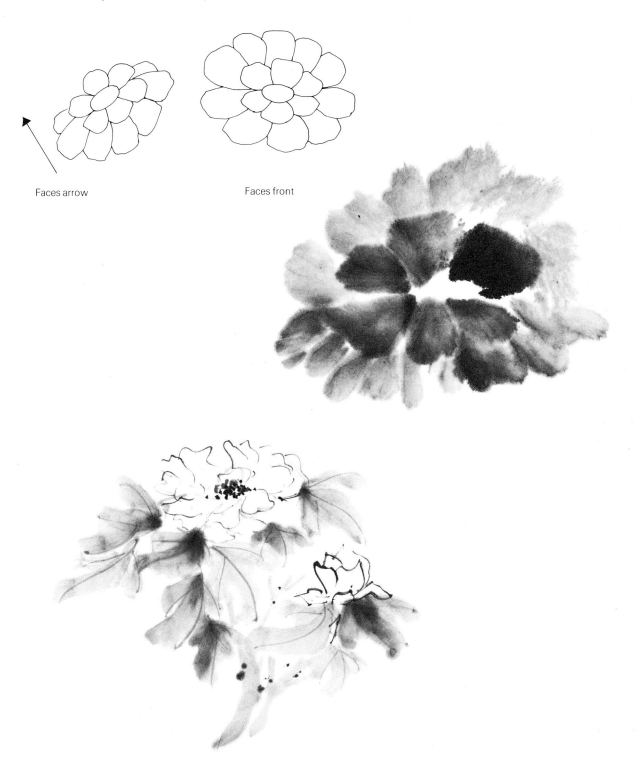

Faces arrow

Faces front

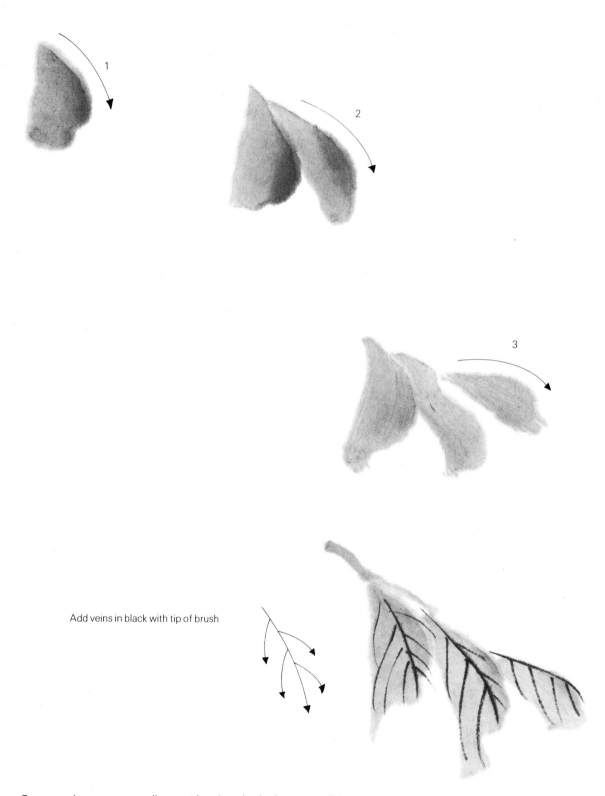

Add veins in black with tip of brush

For peony leaves use a medium wet brush and paint in groups of three.

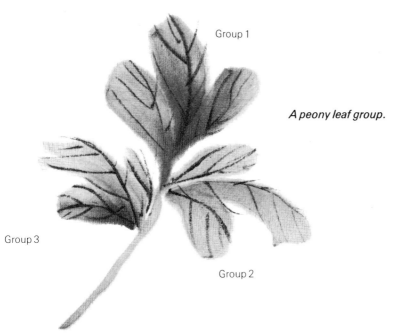

Group 1

A peony leaf group.

Group 3

Group 2

Flower bud

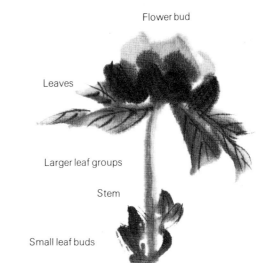

Leaves

A peony bud.

Larger leaf groups

Stem

Small leaf buds

Insects

Bees, wasps, butterflies and other insects can be added to flower and blossom paintings to add life and a touch of realism to the composition. Insects gather round the flowers, collecting their fragrance; they climb along stems and alight on leaves. They can be used to hint subtly at the advent of spring, summer or autumn, by their very presence. Butterflies in spring have pliant wings and enlarged lower parts of a body about to lay eggs. In autumn, butterflies have strong wings, lean bodies and tails lengthened with age. Flying butterflies have their tube-like mouth appendage curled, but, alighted on a plant, the mouth extends to penetrate the flower and draw its nectar. Although insects, including butterflies are usually placed in flower paintings as an ornamental addition, nevertheless due regard should be paid to the season, to maintain a certain degree of realism.

Painting Insects

There are two methods of painting insects, either with the outline or solid-stroke method. Solid strokes contain both wet and dry techniques (*dry* for the soft wings and head; *wet* for the top of the head, the eyes and the hard shiny legs.) Bees are often added, if ink has been splashed, to cover up the mistake. As the Chinese bee is smaller than foreign varieties and is regarded by the Chinese as being an emblem of industry and thrift, it makes a very suitable addition to flower paintings.

Order for painting insects (except some butterflies)

1 Head
2 Body and wings
3 Legs

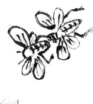
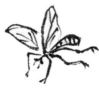

Bees and wasps.

Important reminders

1 Insects usually have four wings and six legs.
2 Jumping insects have strong back legs and flying insects have large main wings.
3 When flying, an insect's body drops, but its wings point up.
4 An insect's legs are pulled up while flying.
5 When alighting an insect stretches its legs.

Notes on Painting Insects

1 A small pointed brush should be used.
2 Hair-line strokes are needed, with even more delicate brushwork for really small insects.
3 The order of painting is eyes, head, thorax, abdomen, wings, legs and antennae.
4 The head of the insect (to be painted first) needs a dark shade of ink, with the eyes always black.
5 Paint the wings of a flying insect with a dry brush, working from the base of the wing where it joins the body and allowing it to fade outward.
6 Fuzzy insects, such as a bumble bee need a dry brush.
7 Shiny insects like wasps or beetles need a wet brush.
8 Solid insects have their legs painted in a series of fine bone-type (like calligraphy) strokes with a wet brush and black ink.
9 Each antenna should be painted in one smooth stroke.

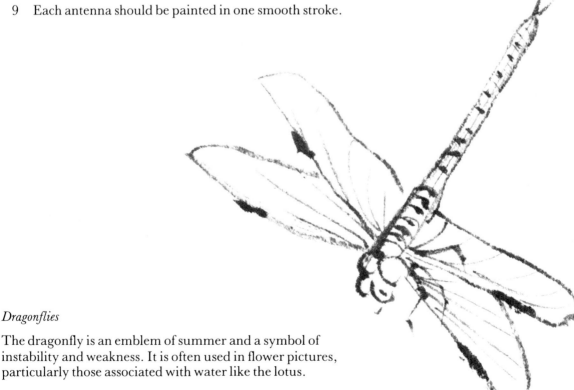

Dragonflies

The dragonfly is an emblem of summer and a symbol of instability and weakness. It is often used in flower pictures, particularly those associated with water like the lotus.

As these insects appear in large numbers before a storm, they are sometimes known as the 'typhoon fly', while the Chinese slang term for them is 'old glassy' because of their large transparent wings. They flit over streams and along river banks, eating harmful insects and are, therefore, much appreciated by the people who live near water.

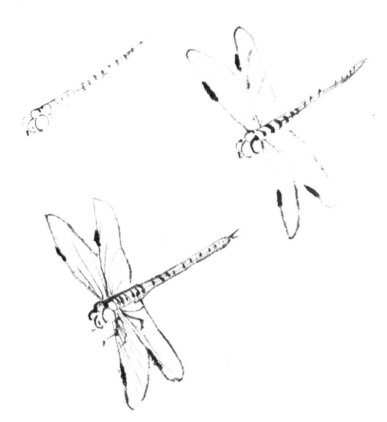

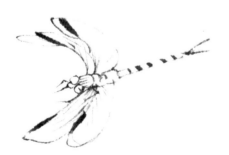

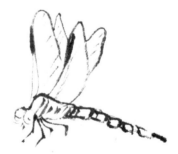

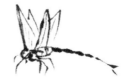

Dragonflies.

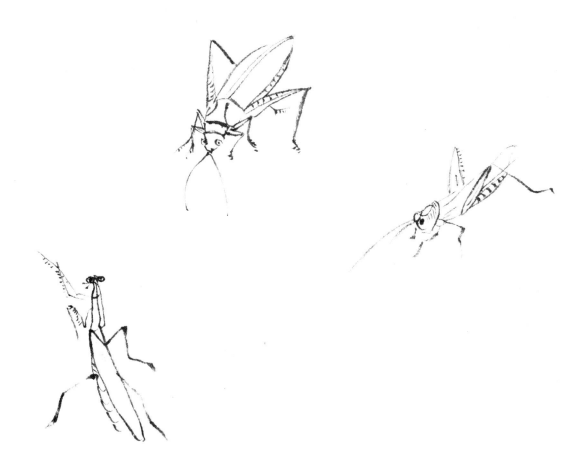

Praying mantis and crickets.

Crickets

The cricket is the triple symbol of life and death and eternal renewal. Like flowers, insects have their own language: a cicada on a weeping willow suggests the song of the insect, mingled with the rustling leaves, caressed by the wind; the praying mantis is a symbol of bravery. Many amulets, pendants, little sculptured jades, represent crickets, bees, butterflies – useless trinkets but meaningful to the lovers who exchanged them. The presence of a cricket in the home was a sign of good luck; on hearing it poets experienced a feeling of tender melancholy. An ancient ode of Che-king says, that the first song of the cricket is the signal for work to the weaver. Women in princely harems kept them in little golden cages that they placed near their pillows at night, so that they could listen happily to them which would ease their loneliness.

Butterflies

The butterfly is not only a symbol of summer but is also regarded as an emblem of joy, since the Chinese philosopher Chuang Tsu once had a dream in which he became a butterfly, happily flying from flower to flower sipping nectar. The same Taoist philosopher regarded the butterfly as a sign of conjugal felicity, perhaps the Chinese version of Cupid.

 Although when painting insects, the head is usually painted first, this is not always so in the case of solid-stroke butterflies. Since the wings are the most important part of the insect they are painted first.

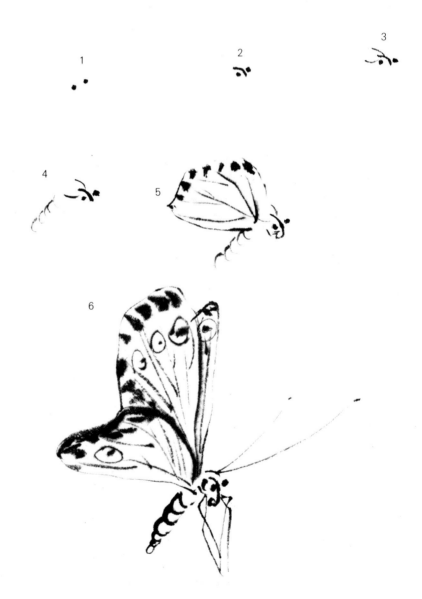

Order for painting butterflies.

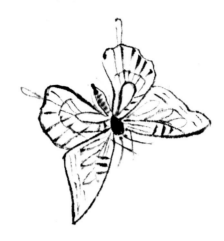

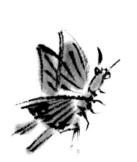

Special notes on butterflies

1 When flying, only half the body is visible.
2 At rest, the whole body is visible.
3 The butterfly has two antennae on its head.
4 The mouth is in between the antennae.
5 Flying in the morning, a butterfly's wings are straight up
 opposite each other.

Before a Chinese artist begins to paint, many hours have been spent in watching butterflies, for instance, or looking at the different varieties of insects, in flight and at rest. Every single element of nature is worthy of time and attention to the artist who wishes to portray, albeit impressionistically, the real, living world. The descriptions given here and the painting instructions for insects may seem to be very formal, but they should only be regarded as an aid, not a substitute for the artist's own eyes. One of the accrued benefits of an interest in Chinese traditional painting is that a better and more intense way of looking at things develops unobtrusively. Seeing, instead of merely looking, becomes an everyday occurence. Even in the centre of a big city, there are bees and other insects to be seen and admired. The painting should follow the observation, so the ideas and information put forward in this section are only a pointer as to where and how to look, if this is the area of interest which fascinates you most.

Birds

Birds are rarely painted by themselves. They sit on the branch of a tree, pause near a flower or rest at the side of a watery pool. They help give life and movement, albeit gentle, to the calm, unruffled serenity of the traditional Chinese flower and blossom paintings. They also refer symbolically to character traits or imply unstated associations. A crane suggests longevity (the Chinese believe that the bird lives to 1,000 years of age), so for an

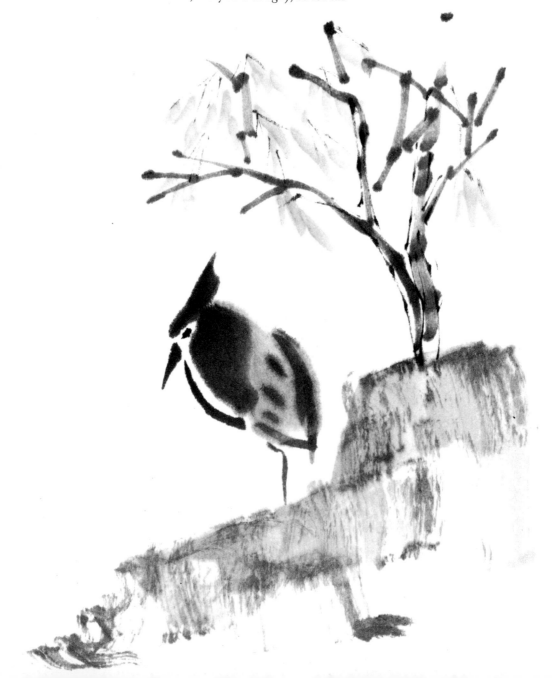

old man's birthday, a crane under a pine tree is considered lucky. Mandarin ducks and swallows often occur in pairs – ducks on a water lily pool or swallows among willow trees mean happy matrimony. Ten magpies are a very lucky omen and usually appear in large official celebratory paintings. The chart on page 88 gives some idea of the symbolism attached to the birds which feature most often in Chinese painting.

Painting Birds

The Chinese say 'To paint a bird, do not go away from the form of an egg'. A bird begins life in the egg and that is also the basic body shape. Two egg-shaped ovals provide the framework for the bird.

Birds are hatched from eggs and their shape closely follows that of an egg, with head, tail, wings and feet added. The tail grows at the end of the oval.

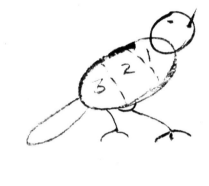

If the bird is divided into three sections the third section is where the legs go.

If a bird is divided into five sections, the wings are in the upper three sections.

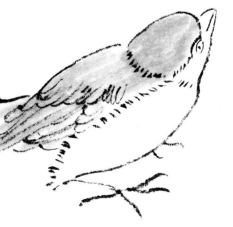

81

 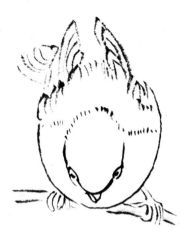

The small circle, which represents the head, can be moved inside or outside the body egg shape.

 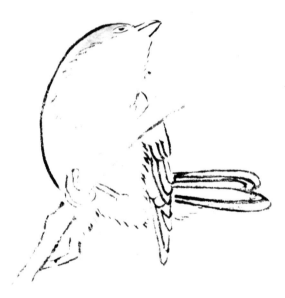

The preceding pictures give the general body shape and format. However, when starting to paint the bird there is an accepted Chinese order of painting which has to be followed. Since the bird must first be able to eat and then to see, the first part of the bird to paint is the bill. Next, paint the eye that is near the roof of the bill.

Although, occasionally, the eye can be painted before the beak, the eyes and beak are *always* painted before the body of the bird. Following the beak and the eyes, the head should be completed, then the bird's back, wing feathers, breast feathers, tail, legs and feet.

The two diagrams explain the order for both the 'brush-line' and 'solid-stroke' methods of painting birds. The bird can then be placed on a branch or in a tree as appropriate. Both methods use a fine brush for the beak, eyes and claws.

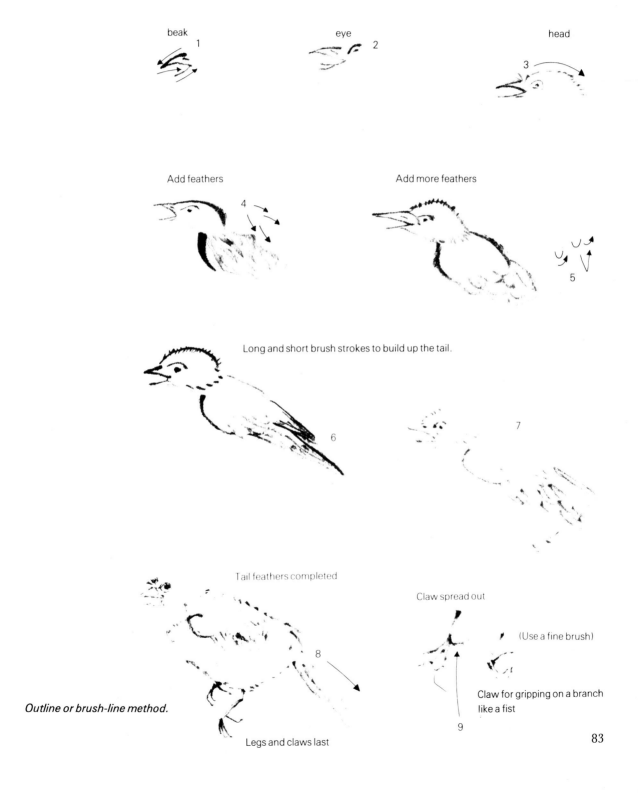

beak

1

eye

2

head

3

Add feathers

4

Add more feathers

5

Long and short brush strokes to build up the tail.

6

7

Tail feathers completed

8

Claw spread out

(Use a fine brush)

Claw for gripping on a branch like a fist

9

Outline or brush-line method.

Legs and claws last

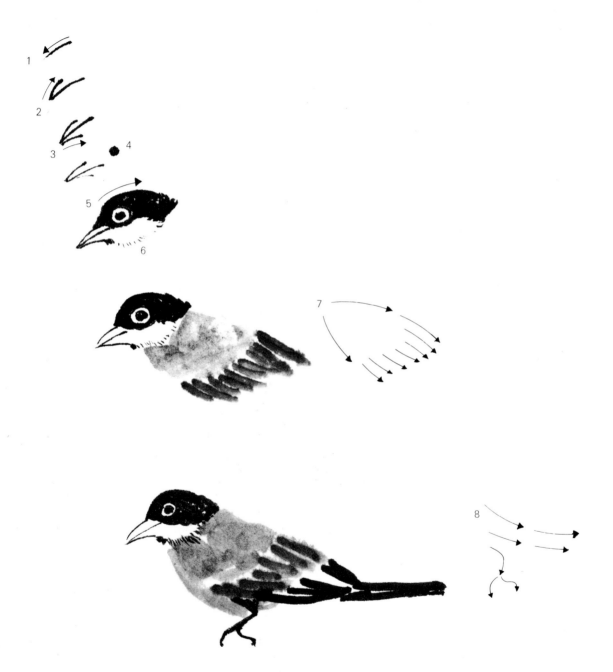

Solid-stroke method. Fine brush *for eyes, beak and claws.* Medium brush *for head, body and feathers.*

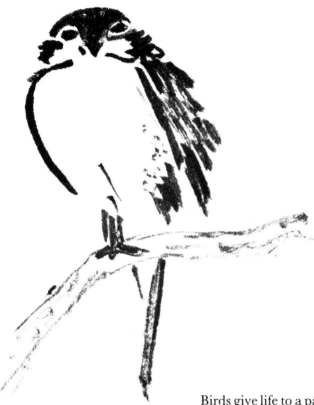

Birds give life to a painting of a rather static branch, or tree, and can, therefore, be painted in a rather quiet, indistinct way. Alternatively, the bird can form the main element of the painting and, as such, will be required to demonstrate rather more of its own character. Some painters are expert in the art of depicting two or more birds in natural interaction in a fine and detailed manner, while Chai Pai Shih could convey the fluffiness of a baby chicken with three wet brush strokes.

As with all other subjects in traditional Chinese Painting, it is necessary to observe and enjoy birds in their natural habitat until a clear picture can be retained in the mind, before attempting to commit brush to paper. This observation of nature is a pleasure in itself and one of the many side benefits to be obtained from the study of this ancient oriental art form.

The Chinese are so enamoured of their birds that, like a pet, they take them out for walks, either still in their cages, or perhaps sitting on their shoulder.

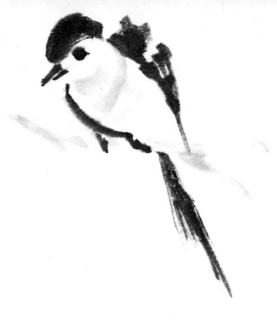

This bird has space below and may fly down into the picture.

Composition

Arrange your flower and bird paintings so that they both look natural. In some places things may appear crowded, in other areas of the picture there may be much open space. According to the ancient Chinese, 'Where expansiveness is required, let there be room for a trotting horse, where compactness is required, let not a needle pass through'.

By putting the bird in one corner of the composition, he has the space to fly into the whole area.

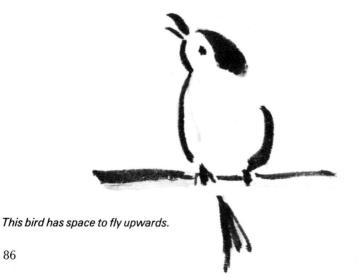

This bird has space to fly upwards.

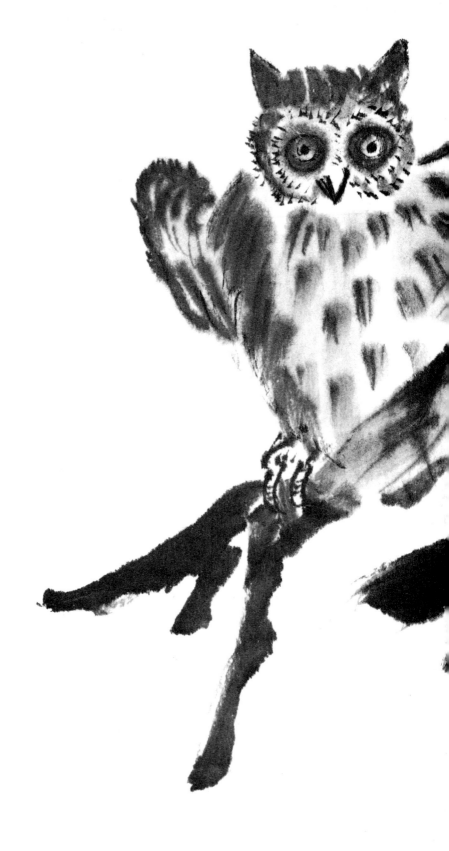

Bird Symbolism in Chinese Art

Name of bird	Legendary Significance	Symbolic Force	Association
1 Cock	Symbolises the pleasures of a country life through five virtues. 1　A crown on his head marks his literary spirit. 2　Spurs on his feet mark his warlike disposition. 3　He is courageous, for he fights his enemies. 4　Benevolent, as he calls for the hens to give them food. 5　Faithful in keeping the time.	Embodiment of the male principle Yang	Red cock on the wall of a house – protection against fire. White cock in a funeral procession – drives away ghosts
2 Crane	Next to Phoenix in importance. Conveyance of the Soul of the departed to the Western Paradise.	Long life High official position Messenger of the gods	Pine Trees Snow Winter
3 Crow	Three-legged *red* crow said to inhabit the sun. Presages ill-luck if its cry is heard while negotiating business.	Evil Ill-luck in business	Sun Filial piety
4 Dove	With the pigeon shares suggestion of useful long life. Decorated the jade sceptre which, in the Han dynasty, was presented to all aged persons.	Long life Dullness Lasciviousness Metamorphosis Orderliness	Good Digestion Faithfulness Impartiality Filial piety Spring
5 Duck	Symbol of a roving life until paired. Then a settled existence.	Felicity Beauty Conjugal fidelity	Lotus Water Reeds
6 Falcon	With eagles and hawks emblematic of keen vision and bold courage. Used on screens and panels.	Authority Courage	Sun Wild Animals Warriors
7 Goose	Symbol of masculinity. Emblem of the conjugal state (as wild geese are said always to fly in pairs).	Faithfulness Seasonal changes	Writing Letters. News from a distance
8 Kingfisher	Fine robes and imposing grandeur. Speed. Retiring nature. Feathers used for appliqué.	Beauty and Dignity	River Weeds Old Trees Flowering Reeds
9 Magpie	Noise. Mischief. Good news. Guests. Rejoicing. Its name means 'bird of joy'.	Among the Manchus, divinity and Imperial rule	Beautiful Maidens Trees and Country Flowers
10 Owl	Concrete and moral evil. Dread, awe, death.	Death. Crime. Horror	Dead Trees Withered Flowers
11 Parrot	Faithfulness between husband and wife.	Fidelity Brilliance	Flowers and Shrubs
12 Peacock	Beauty and dignity. The decoration of the peacock's feather was given for special services.	Beauty and dignity	Flowers and beautiful Maidens

Name of bird	Legendary Significance	Symbolic Force	Association
13 Pheasant	Beauty and good fortune	Beauty and good fortune	Flowers and Humming Birds
14 Phoenix	Imperial dignity. Beauty. Prosperity. Second of the four supernatural creatures.	Beauty and good fortune	Sun, Moon, Clouds and Waves
15 Quail	Military ardour and courage	Poverty Bravery	Millet and Grasses
16 Swallow	Women's voices. Danger. Peking is known as the city of swallows.	Speed Daring	Clouds. Birds and Flowers

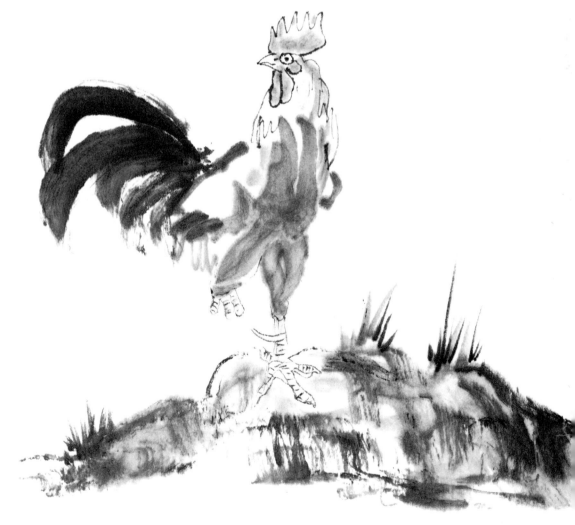

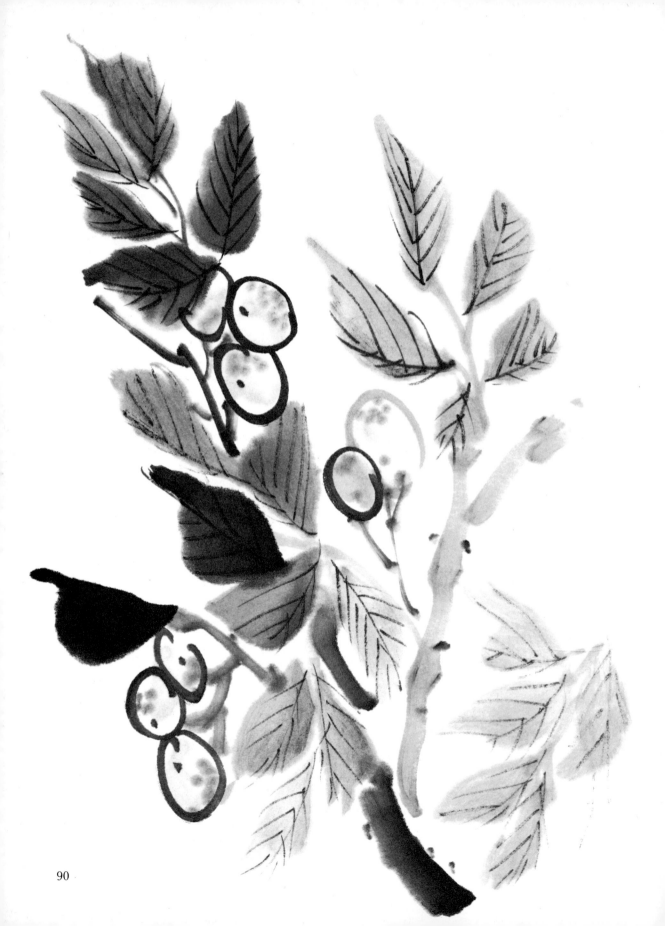

Mounting Techniques

Unless the intention is to make a folding fan, then the next stage towards completing a finished picture is the mounting stage.

When the painting is finished and has had time to dry thoroughly, the fragile easily-creased paper has to be provided with the support it needs to make it manageable. This is done by mounting the absorbent paper on to a card backing.

Mounting

The Equipment required

1. A flat, well-polished metal or plastic surface, such as a freezer-top or a table with a synthetic plastic surface.
2. Starch wallpaper paste (not a synthetic based one) mixed to a slightly thinner consistency than recommended for paper hanging.
3. A large wallpaper brush with coarse bristles.
4. Appropriate mounting board, which should not be the laminated type as this is likely to separate when wet. A card, such as antique Queen Anne board is the most suitable.
5. A sharp knife, metal straight edge, set squares (or square forming device) and a cutting board.

Method

1. Prepare the working surface by ensuring that the flat table top is clean and wax polished.
2. Check that the paste is correctly mixed.
3. Cut the mounting board so that it will completely cover the whole of the painting.
4. Lie the picture, painting side down, on to the table top and flatten it with the hand.
5. Load the wallpaper brush fully, removing the excess; and then in a series of big, bold strokes from the centre of the painting to the outside, completely cover the painting with paste. Any creases or folds can be 'eased' away by patiently brushing the surface with a semi-loaded brush. Care must be taken not to press too heavily and the fingers and hands must be kept away from the wet surface.

6　Check that all brush hairs, lumps of paste or spots of dirt are removed.

7　Holding the mounting card just above the pasted surface, slowly lower it, ensuring that it is located so that the painting is completely covered by the card.

8　Press the two parts together using a wallpaper brush or roller. When you are sure that they have joined together, then carefully peel away the newly mounted painting from the table top, checking that the painting has, in fact, stuck to the card.

9　Allow the mounted painting to dry by placing it flat onto a newspaper.

10　The next stage in the process is to cut the picture to its correct size and shape.

If the picture is to be rectangular (very few Chinese paintings are square) then the best way to arrive at the correct proportions for the painting is by using two 'L' shaped pieces of board which can be moved around until the best position is found, and then the picture can be trimmed with a sharp knife.

Empty space remains an important part of the painting, even at the mounting stage, so the picture should not be cut down too drastically.

Presentation

When the painting is in its mounted, manageable state it can be presented in a variety of formats. Small paintings can be made into greetings cards.

To Make a Greetings Card

1 Divide a rectangular card into three sections. (An appropriate size might be 8in high by 6in wide for the finished card.)

2 Cut out a rectangular hole in the centre section.
3 Place your completed painting behind the rectangular hole.
4 Fold the right hand section, under the picture and glue down. If necessary, coloured paper can be placed behind the picture to produce a tinted background.
5 A message can then be written on the inside section.

Larger paintings can be glued on to coloured backing board to make either vertical or horizontal pictures, remembering that Chinese paintings always have more space above the picture than below it, and also that the sides of the mounting board should be very narrow.

More space left above than below

Narrow side

Narrow side

If the painting is intended to appear as an open fan shape, the following size gives a most satisfactory shape and can be cut out of the backing board and the painting placed *behind* the aperture.

Very small fan-shaped paintings can be used as bookmarks, as can small vertical paintings.

A guide to the dimensions, which may be varied, is as follows: board size 39 × 24 cm; small radius 7.5 cm; large radius 18 cm; sector angle 100° to 110°.

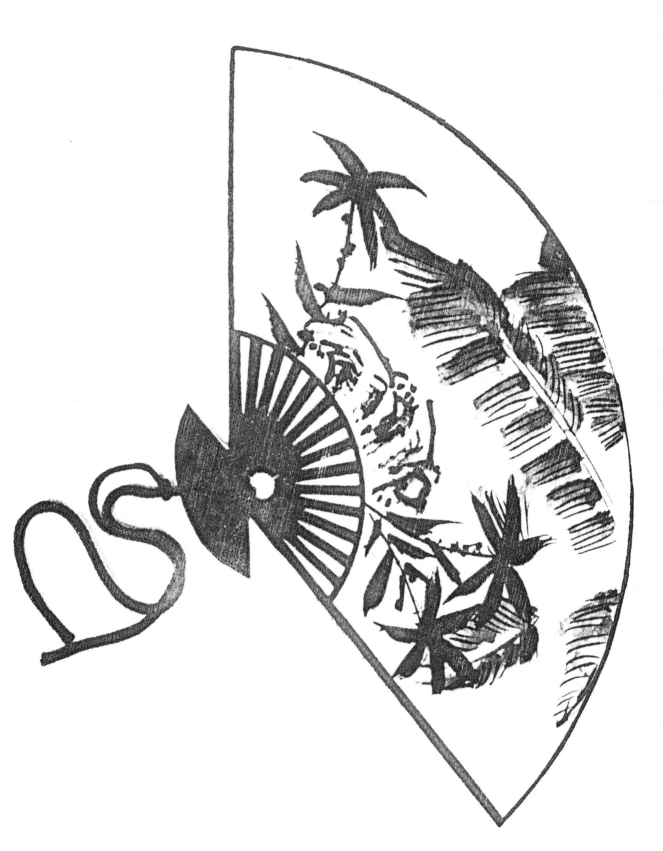

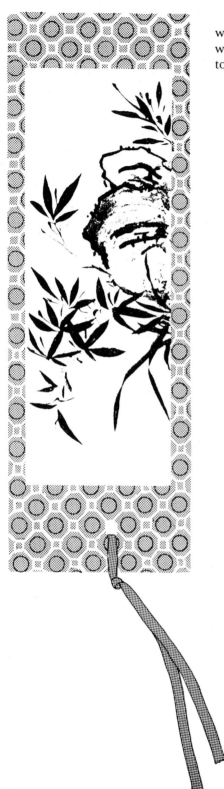

To give these tiny paintings extra life, they can be covered with a transparent library-type material such as Transpaseal, which will help to keep them clean and robust enough to stand up to their bookmarking functions.

The Chinese Fan

The origin of the Chinese fan is not clear. In part it is no doubt derived from the need to find some small, hand-held object which would move the air in the hot and humid areas of China, thereby helping people to keep cool. At the same time, domestic fires for cooking and heating had to be produced by 'fanning' the sparks. For ceremonial occasions, the fan was carried, not only as a necessity, but also to give dignity and elegance to the proceedings. Chung-li Chuan, one of the eight Taoist immortals, said to have lived in the Han Dynasty, always carried a fan as his emblem.

The fan is important in China both for its usefulness and for its decorative and ornamental qualities. There are three basic types of Chinese fan.

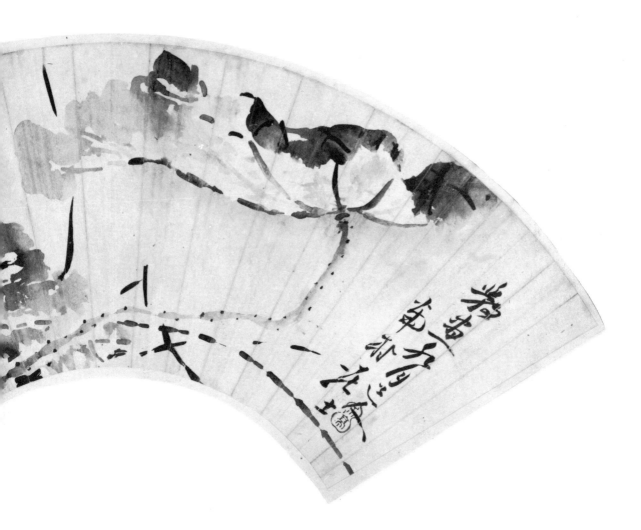

A lotus fan – Kao Feng-Han 1683-1743. (British Museum.)

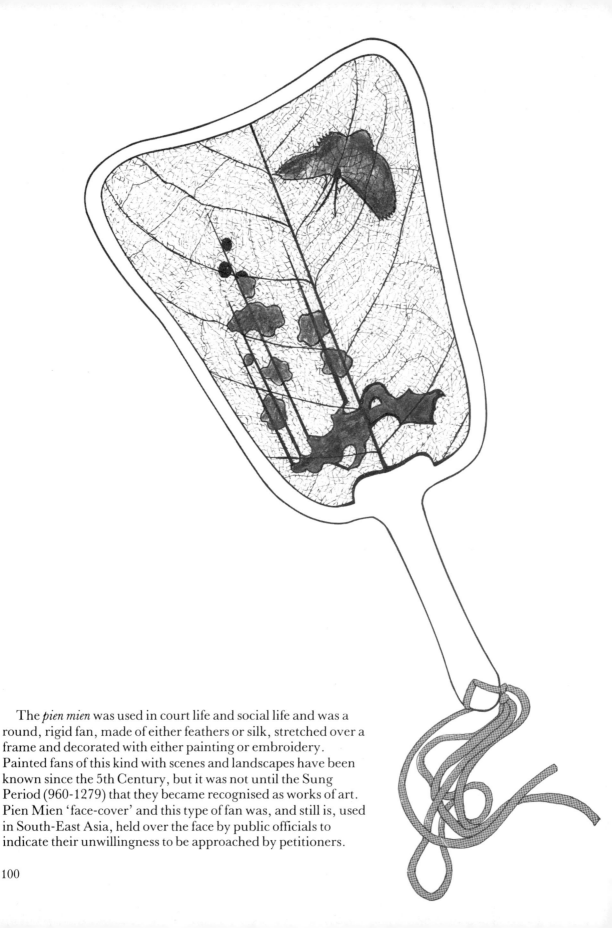

The *pien mien* was used in court life and social life and was a
round, rigid fan, made of either feathers or silk, stretched over a
frame and decorated with either painting or embroidery.
Painted fans of this kind with scenes and landscapes have been
known since the 5th Century, but it was not until the Sung
Period (960-1279) that they became recognised as works of art.
Pien Mien 'face-cover' and this type of fan was, and still is, used
in South-East Asia, held over the face by public officials to
indicate their unwillingness to be approached by petitioners.

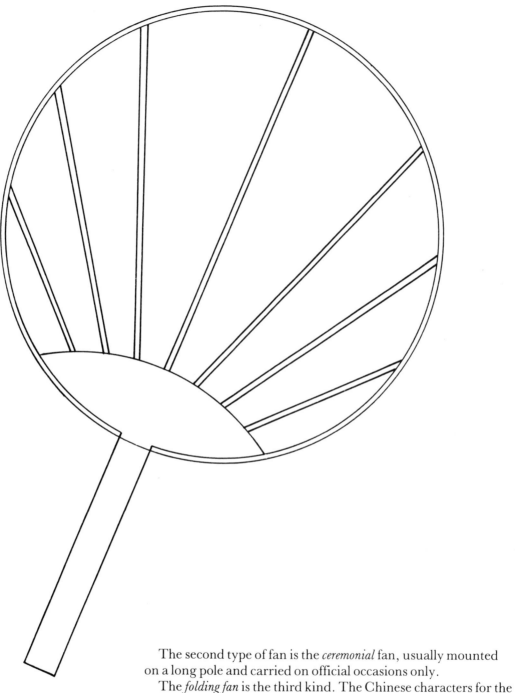

The second type of fan is the *ceremonial* fan, usually mounted on a long pole and carried on official occasions only.

The *folding fan* is the third kind. The Chinese characters for the folding fan mean 'white feathers held in the hand', a reference to the inherent folding and unfolding qualities of a bird's wing. Sometimes the character for paper is included so that a folding paper fan can be described more specifically.

Although there is more than one type of folding fan, the basic reason for their development and increase in popularity was that

they could be carried so easily, either in the sleeve or tucked into the boot. Eventually a special fan case evolved with a pendant attached, so that it could be looped over the belt. The pendant which acted as the weight, later became adapted by the Japanese as *netsuke*.

The Fan as a Format for Chinese Painting

Fans have been used in China from ancient times, the first recorded one being the round version, which could be made of silk, paper, feathers or leaves. The folding fan became popular in the 11th century, being made with a frame of horn, bone, ivory, sandlewood or bamboo. The folding fan was easy to carry in the sleeve or waistband and was used by both men and women.

They were often used as albums with calligraphy or flowers, or both, painted upon them as gifts to friends.

Papers for fans were painted, mounted and framed as pictures without ever having been made into a working fan. In the Sung and later dynasties, landscapes were also painted on fans and in modern times, any subject matter can be adapted to the fan-shaped format.

A fan-shaped hole can be cut out of coloured mounting board and used as the format for a picture. Both paper and material can easily be glued to the reverse of the mounting board and then a backing put on the picture in the same way as if the format had been rectangular. (See page 96.)

Making your own fan is not too difficult. The painting, done on ordinary Chinese paper, should embody rather stronger tones or colours than normal, as the painting will not have a mounted backing. Subject matter embodying strong rather than delicate strokes is better for the fan, as when folded the composition is, of course, divided into sections by the spokes.

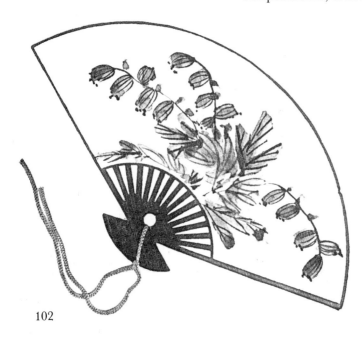

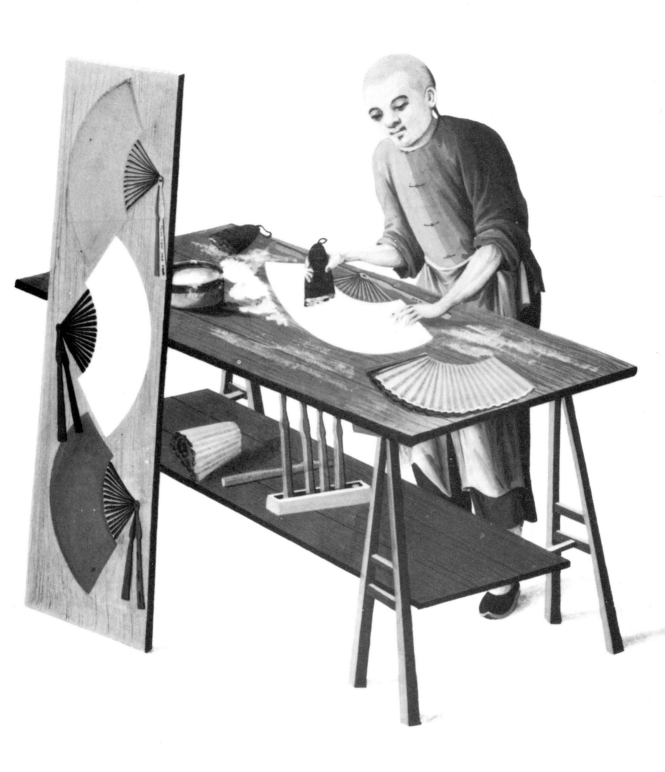

A Chinese watercolour showing one stage in the manufacture of fans, that of glueing the leaf to the sticks. (From an anonymous album, entitled 100 Trades, *in the British Museum.)*

How to Make a Fan

Materials needed: paper fan, scissors or sharp knife, transparent drying paste, Chinese absorbent paper and painting equipment, pencil.

1 Buy a cheap ready-made paper fan from a toy-shop or party supplier.
2 Open the fan fully and mark this shape on to the Chinese paper with pencil dots. (*See illustration.*)
3 Soak the fan in water until the paper comes off, checking that all the glue is removed from the struts.
4 Open the bamboo struts and allow to dry.
5 Your own composition should now be painted within the fan shape and the marked shape cut out at the pencil dot markings.
6 Paste the painting to the first and last struts, using the rounded part (not to be glued) as a guide. The paper

should go *under* the first strut (the *top* of the fan when closed) and *over* the last strut (the *bottom* of the fan when closed). (*See illustration.*)

7 Turn the fan over and spread out the struts evenly, making sure that (a) the spines do not cross each other (or the fan will not open) and (b) that the paper does not go below the 'neck' of each spine. (*See illustration.*)

8 Lift each spine in turn, smooth paste underneath and place spine onto the picture.

9 When dry, any surplus paper can be cut away from the top.

10 When totally dry, refold fan, starting from the top strut.

一千九百八十年
山水景 珍朗

Your Questions Answered

Over a period of years, while teaching and lecturing on the techniques of Chinese painting, there have been some general queries on aspects related to, but not directly involved in, the painting, which have been asked again and again. This chapter provides the answers to some of these queries.

Question 1

Are there any general rules that the painter should follow?

Although traditional painting has accepted methods of representing nature, there are no hard and fast rules which demand that these should continue to be followed, provided that the overall concept of the picture falls within the precepts put forward by 'Hsieh Ho'. In the 'Classification of Painters' published about the year 500, Hsieh Ho listed six basic principles for traditional Chinese painters, of which all but the first can be realised by practice. These 'Six Canons' as they were called, are still observed by contemporary Chinese painters, so it is clear that they are of great importance.

The Six Rules

1 *The spirit and vitality of life and nature should be contained within the painting.* This first and most important of the six rules implies that there is more to a painting than first meets the eye. Additionally, the religious beliefs of Taoism and Buddhism are often visually manifested by the paintings of their devout followers.

2 *The brush creates the structure of the painting.* Control of the Chinese brush in all its manifest complexities and possibilities is almost as important to the quality of traditional painting as its spirit. The very nature of the control necessary to manipulate brush and ink on the painting surface is much appreciated by the connoisseur of Chinese brush painting.

3 *The subject matter of the painting should be recognisable.* Since Chinese painting is, by its very nature, impressionistic, care has to be taken that nature is not distorted too much so that it becomes abstract and unrecognisable. It is not necessary to paint a named variety of flower, or slavishly follow the proportionate size of a butterfly, but too much of a departure from realism is not considered allowable.

107

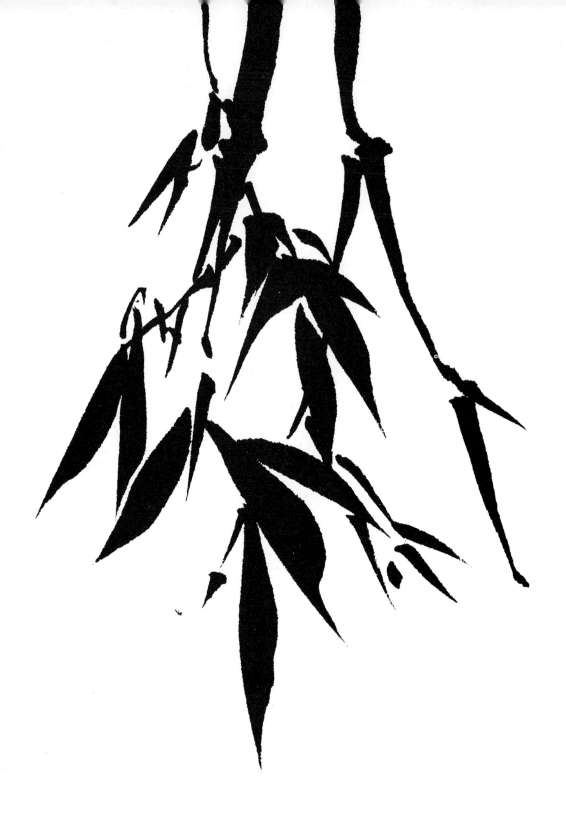

4 *The colour should be appropriate to the subject.* The most important aspect of this rule is to remember that each of 'the seven shades of black' is equivalent to a colour and can be used instead of reds, greens, etc.

5 *A painting should be composed correctly within its format.* The disposition of the subject matter on the painting surface is quite a difficult component of a Chinese picture and especially so for a Westerner. Because space is so much a part of the original conception, there should eventually be whole areas of unfilled painting surface left when the picture is complete. Flowers and branches grow from the sides of the painting instead of arising from a horizontal plane within the picture. There are other compositional elements which also have to be considered when dealing with the different formats more specifically.

6 *Copying from the work of the old masters is the best method of learning.* Practising, by using the compositions of recognised painters is a good method of learning as it immediately removes from consideration the most difficult element of the picture and enables concentration to be focussed on brush use and ink control. The traditional expression *'yu pi, yu mo'* – (to have brush, to have ink) indicates the importance placed on controlling both these Chinese painting elements *together*.

Most books on Chinese painting contain these six rules as they are the accepted principles and of great importance in this traditional art form.

Question 2

In what way does a Chinese painting differ in composition from a Western painting?

Generally speaking, there is more white space left in a Chinese painting than in a Western painting, the proportion often being as high as two-thirds space to one-third painting.

Another characteristic of the Chinese painting is that, in accordance with tradition, more space should be left above the painting (representing heaven), than below (representing earth). The brocade mounting around scrolls echoes this space concept.

Question 3

What are the most important formats for Chinese painting and how did they evolve?

The physical format of a painting influences both the style and composition of the picture.

Wall Paintings Large, flat surfaces painted in strong colours and meant for public viewing, were the first of the Chinese traditional paintings. Very few of these have survived, but some good examples of Buddhist paintings were found in the caves of Tun-huang.

Screens Many different kinds of screens were used in Chinese houses, some with paintings put directly on to the treated wood and others having silk picture panels. Some screens consisted of a single panel mounted on legs, others had several vertical panels made into a folding screen. The screens had many uses. In the Han Dynasty (202 BC-AD 220) screens were placed behind honoured guests, used as room dividers, as single panels on the sides of couches and palanquins or outside as wind-breaks.

Handscrolls were small personal paintings, 9-14 inches high, they could be less than 3 feet long, or as much as 30 feet. A round wooden roller was attached to the left of the scroll and a semi-circular rod to the other end. Sometimes inscriptions were added to the paintings.

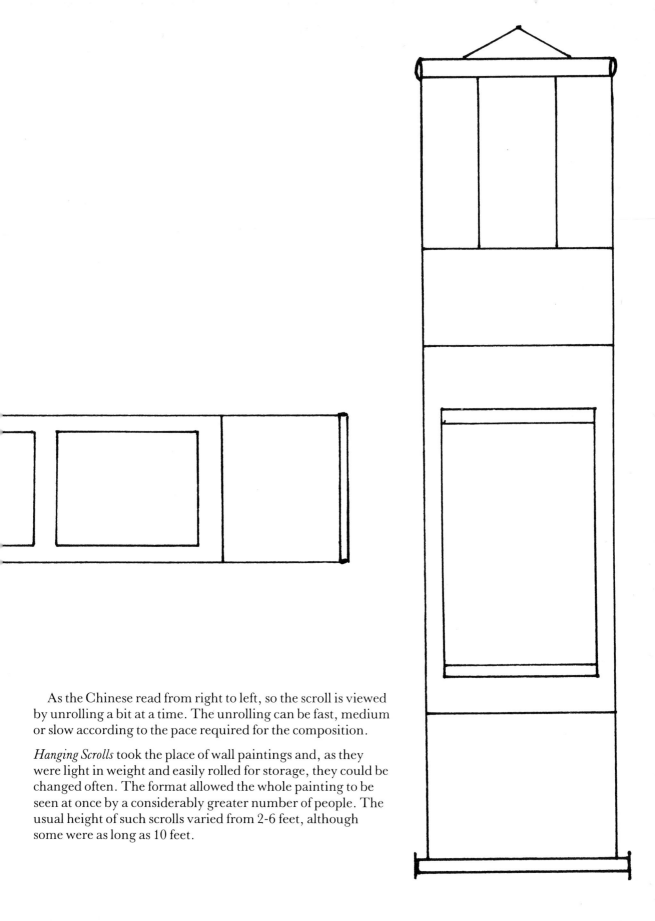

As the Chinese read from right to left, so the scroll is viewed by unrolling a bit at a time. The unrolling can be fast, medium or slow according to the pace required for the composition.

Hanging Scrolls took the place of wall paintings and, as they were light in weight and easily rolled for storage, they could be changed often. The format allowed the whole painting to be seen at once by a considerably greater number of people. The usual height of such scrolls varied from 2-6 feet, although some were as long as 10 feet.

The Album provided a small-scale format, very popular in the Southern Sung period (1126-1297 AD), where individual or paired leaves could be put together in a folding manner.

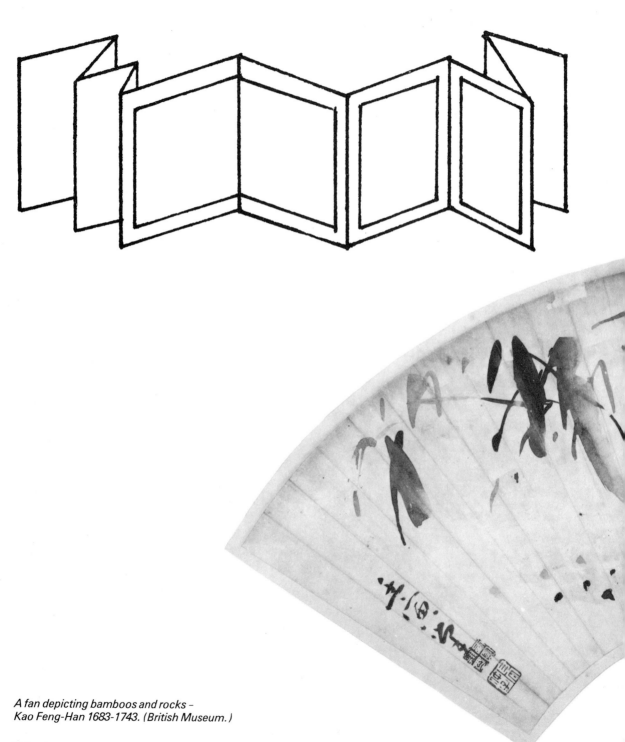

A fan depicting bamboos and rocks –
Kao Feng-Han 1683-1743. (British Museum.)

Fans have already been described in the two most popular forms – the curved accordion-folded type usually made of paper and the stiff, often rounded fan, typically made of silk. It was often the case that the folded paper fan was two-sided, one side being calligraphy, probably a poem and the other side a painting related to the poem.

Finally, it needs to be said that paintings could be altered from their original format. Fans, for instance, were often made into album leaves; screen panels were taken out of their wooden surround and remounted as hanging scrolls.

Most of the formats described have no built-in protection for the paintings themselves, but modern pollution is such that where possible vertical and horizontally mounted paintings are put into narrow, plain frames and protected by glass.

Question 4

Why do some paintings have so many seals on them?

Most traditional Chinese paintings have their authorship certified by a seal impression placed on the painting in cinnabar red. The seals, often carved in soapstone, are usually round or square, $\frac{1}{2}$ in to $1\frac{1}{4}$ in in height, depending upon the size of the painting, and may appear either in intaglio (characters appear white because they have been carved out of the stone), or in relief (characters appear red because the stone has been carved away to leave the characters standing out of the stone).

The God of Longevity seal illustrated has been carved out of soapstone to decorate the author's seal, which is contained within the base. The decorated stone box has 11 seals of various sizes with carved butterflies and bees showing on their tops. They can be purchased like this without anything carved into their bases and they await the painter's choice.

Cinnabar paste used for the seal is shown in a decorated ceramic pot in a brocade box. These items were art objects in their own right and formed an additional decorative element to the items on the scholar's or painter's desk. The cinnabar paste is obtainable in a tin, which is rather cheaper.

The paste, which is red, is made up of mercuric oxide paste, ground silk and oils. This combination is poisonous and should only be used to make the seal impression. Black or blue seals are added to paintings during periods of mourning.

A seal placed in the vacant corner of a painting may enhance the composition, particularly where there is such a striking colour contrast as that between the vermilion of the seal and the black of the ink. Some of the author's seals are illustrated.

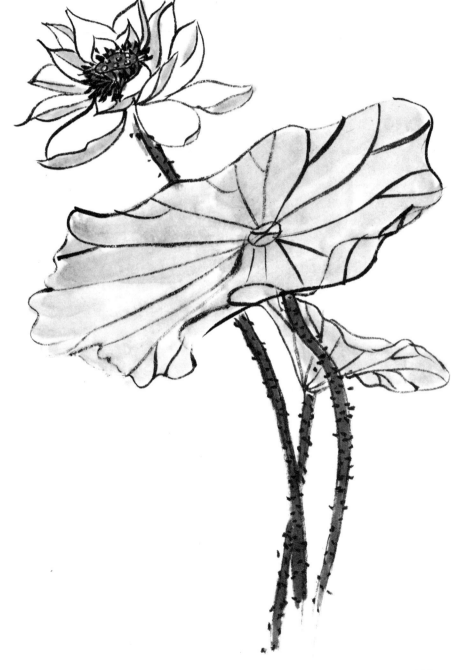

117

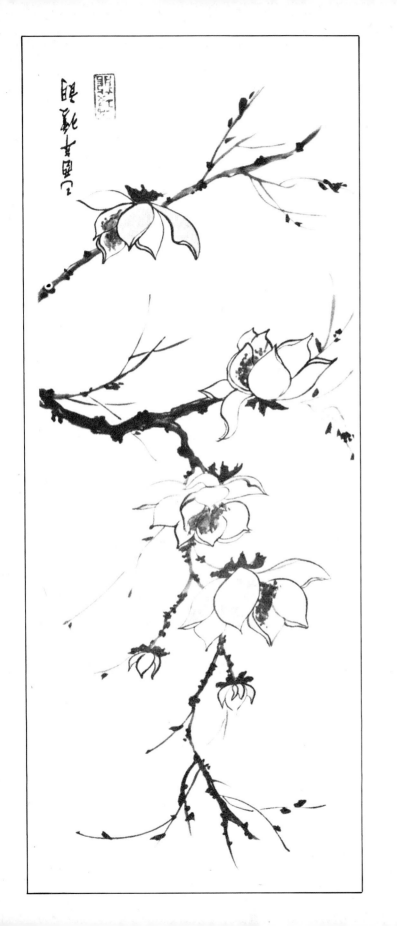

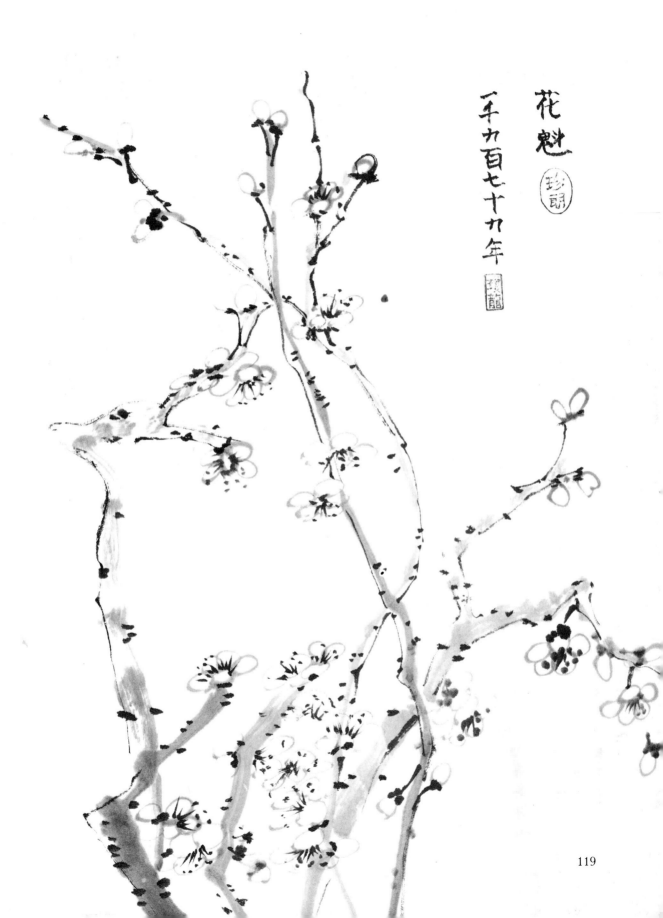

花魁 珍朗

一千九百七十九年

119

Every Chinese artist acquires a number of special names or 'hao'; some are self-selected, others are nicknames given by friends. The painter will probably have a seal for each of these names and one for the special name of the studio work-place. Chao Meng-fu christened his studio the 'Gull-Wave Pavilion' and Wu Chen named his 'The Plum Blossom Retreat'.

In addition, from late Ming (16th and 17th centuries) onwards, painters and owners also added seals which contained quotations, philosophical sentiments, or comments on when and how a painting was commissioned.

The first seals appeared on a painting during the T'ang emperor's reign in AD 627-50 and grew to popularity by the 12th century. From the 16th century onwards, collectors and inscription writers added their seals to those of the painter himself. These additional seals showed appreciation, ownership and connoisseurship, but when the number of seals added reached thirty and included large seals which used up the empty space so essential to the painting, or in some cases actually impinged upon the painting itself, then the general result was to spoil the composition. However, the seals have helped to authenticate paintings and chart the history of those who owned the picture, telling when and where it was exhibited, as well as who had admired it during these periods.

Question 5

M'ing, T'ang and others are terms often referred to when describing the dates of a painting. What do they mean?

Chinese history is divided into Dynastic periods. The divisions occur at the times when the ruler or ruling parties changed, for whatever reason. Artistic developments were often initiated as a result of these changes, or sometimes because a prolonged period of peace allowed progressive ideas to develop and mature.

Perhaps the most famous of all these periods is the Ming Dynasty, which because it lasted for some 300 years enabled artistic ideas to progress through a time of great stability.

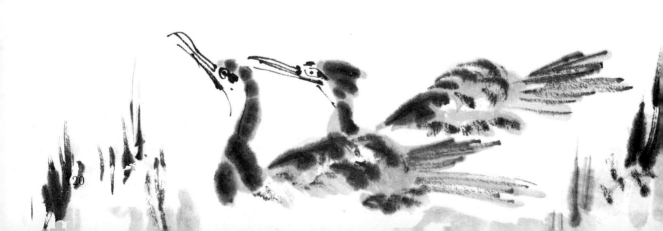

Chronology of Chinese Dynastic Periods

BC 2000-1520	Hsia
1520-1030	Shang
1030-221	Chou
221-207	Chhin (or Ch'in) This was the dynasty of the first emperor of a unified country. (China is named from Ch'in).
207-AD 220	Han
AD 220-581	The Three Kingdoms and the Six Dynasties
581-618	Sui
618-906	Thang (T'ang)
906-960	The Five Dynasties
960-1126	Northern Sung
1126-1279	Southern Sung
1279-1368	Yuan (Mongol)
1368-1644	Ming
1644-1911	Chhing (Manchu)
1911	Republic

Question 6

Is there any difference between Chinese and Japanese Painting?

Japanese painting technique, called Sumi-e, is similar in many ways to Chinese painting, although the two are not identical.

The brushes used for Japanese painting are like the Chinese ones, but the number of hairs used in their construction is less, so that the brush is not able to hold a large amount of ink. Some of the strokes used in Chinese Painting are, therefore, not feasible in Japanese painting. Regarding the actual contents of the paintings, although the subject matter is often identical – bamboo, flowers, birds and insects – as described in this book, nevertheless, where Chinese painting is quiet, gentle and delicate, Japanese compositions are strong and full of movement. If colour is used it is vibrant and often embellished with gold, unlike the muted tones of Chinese paintings.

Question 7

This book is devoted entirely to ink painting. What additional information is needed to paint in colour?

Early Chinese paintings used natural pigments pounded up with pestle and mortar. The modern alternatives are colour sticks, which are made of real pigment and ground on a stone in the

same way as the black ink stick, or watercolours in pots, tubes or pans. The less additives amalgamated in the colour, the better suited the paint is to the natural absorbent paper. Gouache is not suitable, nor is poster colour.

For leaves, bamboo and stems, green or brown can be mixed with the black ink. Outline flowers can be filled in with colour, after the black ink has thoroughly dried. Treated silk is a good medium to use instead of paper, if colour is to be the most important feature of the Chinese painting. Many landscape compositions are painted in shades of black and then given light colour washes as appropriate. More information about the use of colour and about landscape painting is contained in *How to Paint the Chinese Way*.

It is even more important for colour painting than it is when using only shades of black to ensure that the paint soaks *into* the paper and does not sit thickly on the surface. This is vital for the

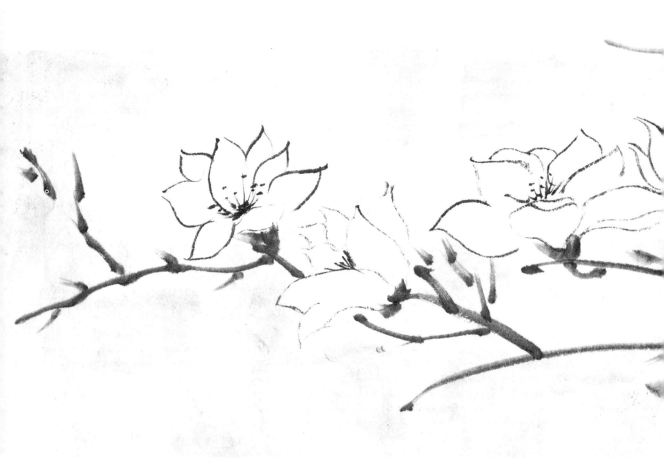

mounting process to be successful. If, when trailing the fingers lightly over the surface of the dried painting, the paint can be felt as a raised area, then it is possible that running will occur when the picture is wetted during mounting.

The technique and the brushwork remain the same for colour as for the shades of black.

Question 8

Some of the Chinese paintings have coloured backgrounds. How is this achieved?

It may be that the picture was painted on coloured rice paper. This type of rice paper, which has been dyed to achieve the colour, is not easy to use as a considerable amount of its absorbent properties have been used up by the dyeing process. It is most suitable for gold outline flower and bird painting.

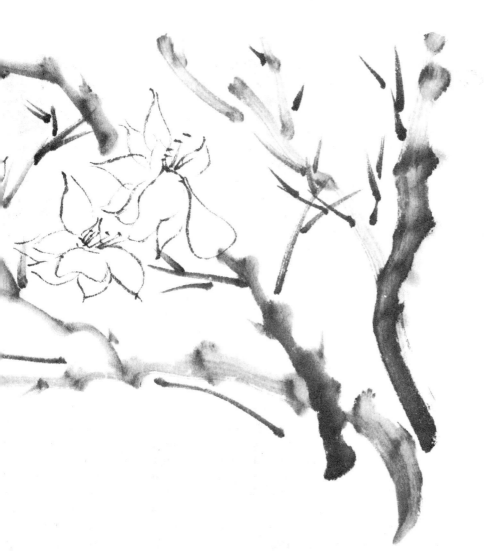

Although obtainable with difficulty in some countries, it is not yet available in the United Kingdom.

Ancient paintings have a subtle brown tint, sometimes the result of the original paper being made from a coloured natural fibre, such as mulberry or bamboo. However, there was also a special liquid washed over paintings as anti-moth and insect treatment. This liquid caused the paper to turn brown with age and accounts for the ancient parchment colour of many of the old scrolls.

It is possible to achieve this ancient brown colouration by washing over a composition, painted on white paper, with a strong tea solution. This is very successful provided, a) the ink is dry before the wash is added, b) the wash brush is soft and does not scrape the paper, and c) the tea is put on carefully in horizontal strokes which leave neither gaps nor overlaps. Of course, watercolour paint could be used as the wash, but the natural pigment of tea blends more realistically into the paper. Another method of achieving a coloured background is to mount the white paper painting on to a coloured board instead of a white one.

Question 9

What are 'Yin and Yang'?

Ancient Chinese mythology describes the world as being a hen's egg, which separated into the yolk and the white; one representing the heavy elements which formed the earth, and the other part of the egg, the light, pure elements which formed the sky. These were *Yin* and *Yang,* representing the female (passive) and male (active) elements respectively.

The symbol shows that Yin and Yang are so closely interwoven that each does not exist without the other.

Together Yin and Yang constitute the Tao (the eternal principle); individually Yin is negative, dark, earth, moon, even numbers, valleys and streams; Yang is positive, light, heaven, sun, odd numbers and mountains. In painting, brush and paper, ink stick and ink stone, seal and cinnabar paste, water and mountains, are all part of the duality of Yin and Yang.

Question 10

What influence did religion have on Chinese traditional painting?

There were two Chinese religions that had a very positive influence on painting, Taoism and Buddhism. There is a third, very powerful religious influence on Chinese cultural life and that is Confucianism, but this religion did not have such a powerful effect on painting. Buddhism and Taoism dominated the Chinese imagination, while Confucianism governed Chinese conduct.

The founder of Taoism (pronounced *D*aoism) was Lao Tsu, who was born in 604 BC. His philosophy was never to interfere but let things take their natural course. The religion still remains today with the Taoist paradise always being shown in Chinese art as mountains, lakes and streams, bridges and pine trees, in fact it is typical natural scenery. The basic writings are collected together in the 'Tao Te Ching' which has been translated into many languages and in many ways verbalises the essence of Chinese traditional painting.

Buddhism is also a very popular religion in China and has inspired many paintings, particularly of the various different Buddhas. Introduced into China in AD 67, the five basic precepts of Buddhism are: 1 Slay not that which hath life; 2 Steal not; 3 Be not lustful; 4 Be not light in conversation; 5 Drink not wine.

Modern Chinese have a very open attitude to religion in that they often take the best from each of the three most popular religions and combine them to form one more enjoyable in the observance.

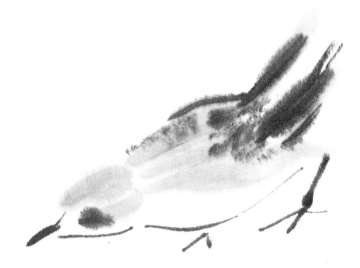

Bibliograpy

How to paint the Chinese Way, Jean Long, Blandford Press 1979
Outline of Chinese Symbolism and Art Motives, C. A. S. Williams, 3rd edn., Dover Press
The Chinese Eye, Chiang Yee, Indiana 1964
Ch'i Pai Shih, T. C. Lai, Swindon Book Co., Hong Kong 1964, reprinted
The Mustard Seed Garden Manual of Painting, ed. Mai-mai Sze Bollingen Series, Princeton University Press 1956, reprinted 1978
The How and Why of Chinese Painting, Diana Kan, Van Nostrand Reinhold 1974
Chinese Painting Techniques, Alison Stilwell Cameron, Charles E. Tuttle 1968
Fans from the East, Debrett's Peerage Ltd, 1978
Chinese Theory of Art, Lin Yutang, Wildwood Press
China Reconstructs (a monthly magazine available from Guanghwa Co. Ltd), published by Guozi Shudian, Beijing, China

Suppliers of Chinese Painting Materials

Collet's Chinese Bookshop, 40 Great Russell Street, London WC1 3PJ
Guanghwa Co. Ltd, 7-9 Newport Place, London WC2
Paul Wu Handicrafts, 64 Long Acre, Covent Garden, London WC2

Index